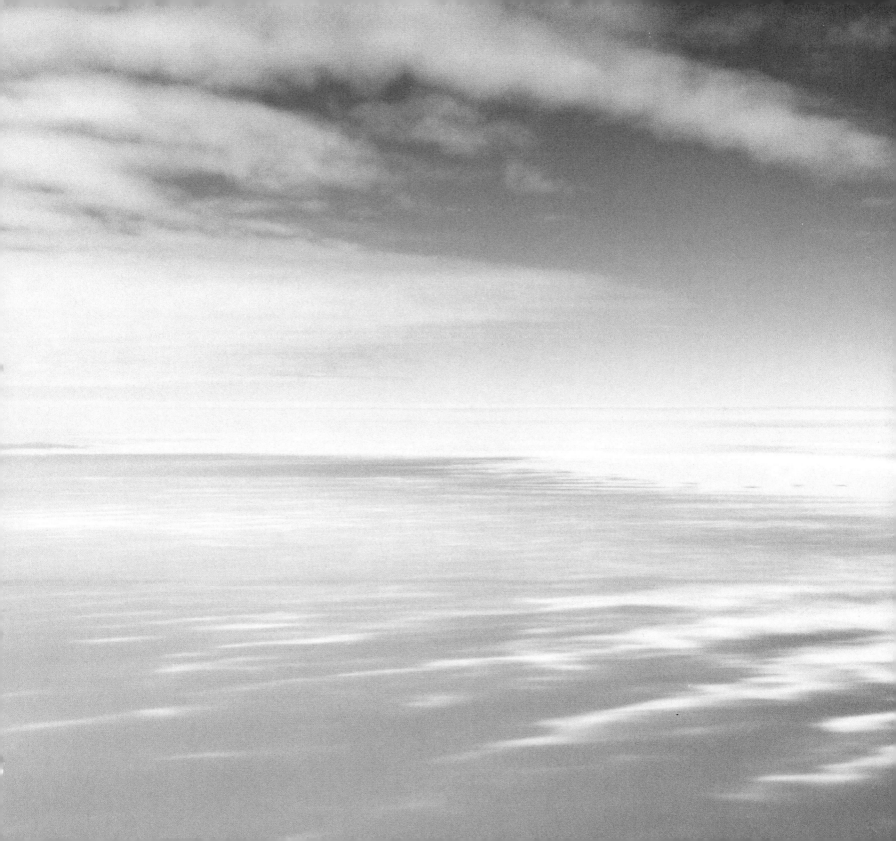

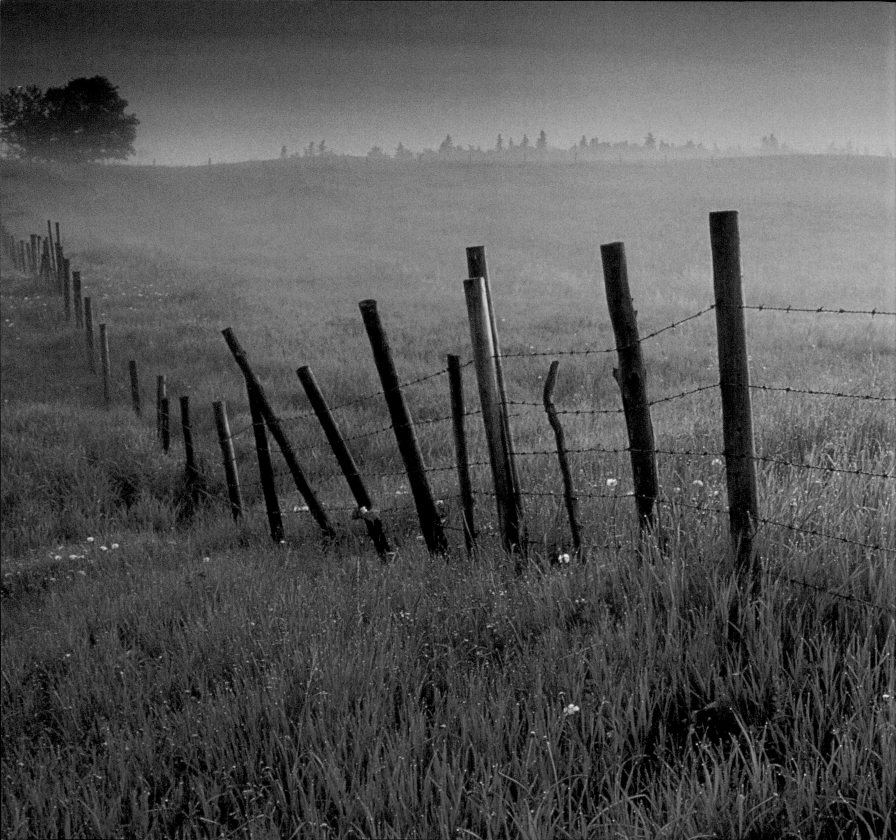

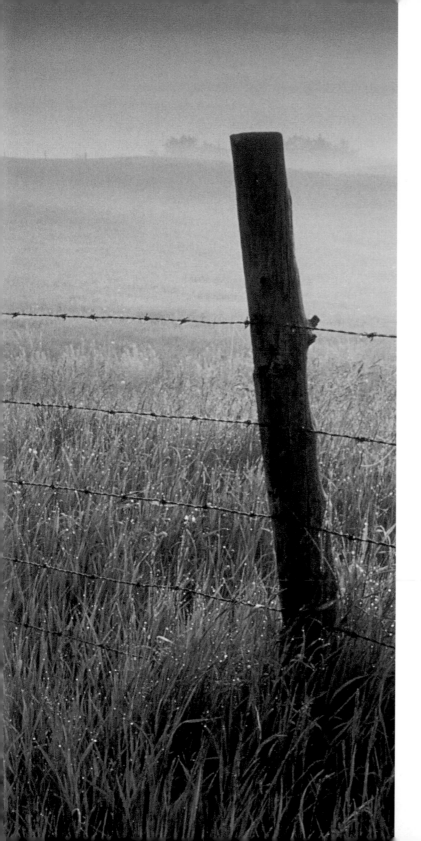

pilgrimage

The Spirit of Place

Gideon Bosker and Lena Lenček
with Mittie Hellmich

CHRONICLE BOOKS
SAN FRANCISCO

To our parents, Rado and Nina Lenček and Dorka Bosker, who,
in the process of making their own pilgrimages, got us started on ours.

⊹ ⊹ ⊹

Library of Congress Cataloging-in-Publication Data available.

ISBN 0-8118-3473-5

Manufactured in China

Distributed in Canada by Raincoast Books
9050 Shaughnessy Street
Vancouver, British Columbia V6P 6E5

10 9 8 7 6 5 4 3 2 1

Chronicle Books LLC
85 Second Street
San Francisco, California 94105

www.chroniclebooks.com

page 1: Ross Ice Shelf, Antarctica
page 2: Sunrise, Sherwood Park, Canada

Acknowledgments

This book has required the assistance, talent, and inspiration of many publishing colleagues, friends, and artists. First, we would like to express our gratitude to all the photographers who agreed to contribute their work to this book. Their passion for chronicling and interpreting remarkable planetary outposts has produced a collection of diverse and unpredictable images that distill the essence of a place, that reflect an ecstatic engagement with the earth, and that inspire a profound love for monumental and soul-elevating spaces that make everything else seem insignificant. Without their artistic vision, drive for exploration, and technical skills, this book would not have been possible.

We also are indebted to a group of editors and researchers who, over time, encouraged our interest in pilgrimages, photography, and in producing books in which word and image became greater than the sum of their individual parts. In particular, we are grateful to Bill LeBlond, Richard Pine, Wendy Wolf, and Bruce Good. Other friends and colleagues whom we would like to thank for providing insights into the process of pilgrimage-by-photography include Tara Wapelhorst, Janet Haymes, Mark Gossett, Jonathan Harris, Jonathan Schiller, David Culverwell, Bianca Lencek-Bosker, Tanya Supina, and Christopher Di Lascia. We are especially indebted to Mr. Di Lascia, who created an inspired body of poetry linked to the subject of pilgrimage, and who has kindly consented to the inclusion of his work in this book.

The process of producing a book in which diverse images are quilted together to create the desired visual and emotional impact requires the services of a designer with an expansive, intuitive vision who appreciates that books can be seen as a visual symphony, or frozen music. We are especially grateful to Vanessa Dina for making this book sing on the page, and for her exacting work to ensure that page by page, readers of this work would, indeed, embark on a pilgrimage to a better place.

There are a few key individuals in every project who are linchpins to success or failure. First, we would like to thank Anne Bunn, assistant editor at Chronicle Books, whose diplomacy, impeccable taste, organizational expertise, and editorial insights have played an immeasurable role in bringing this project to completion. In addition, we would like to thank Mittie Hellmich for her diligence and professionalism in the area of photo research and alliance building in the photographic community.

Finally, we would like to thank Sarah Malarkey, executive editor at Chronicle Books, who, with this book, continues to take us on an enduring pilgrimage through the ineffable world of ink, chrome, and paper. Without her mission statement—advancing the world of book publishing so it can take readers to life-affirming places that they may otherwise not experience—this book would not be what it is. When it comes to the alchemy of turning print and photo into passion and peak experience, Ms. Malarkey is a giant among editors, and for this unique talent, we express our deepest gratitude and admiration.

—Gideon Bosker and Lena Lenček

Somewhere between the heavens
And Earth,
The murky borders of eternity
Dissolve into perfection—
Places so ephemeral
They cannot be possessed,
Yet real enough to confound us,
Into loving.

<div style="text-align: right">

— **Christopher Di Lascia**
The Spirit of Place

</div>

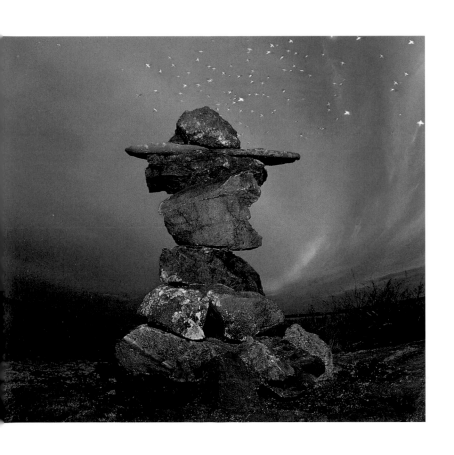

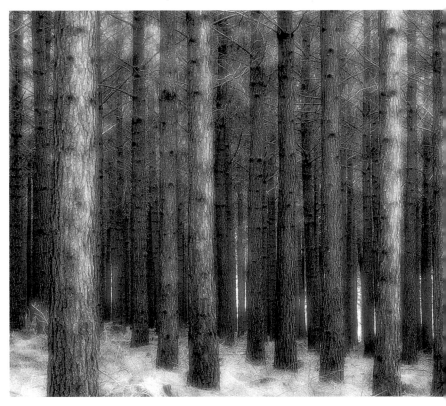

Eastern Arm of Great Slave Lake ÷ Northwest Territories, Canada
Pine Forest ÷ Near Graskop, South Africa

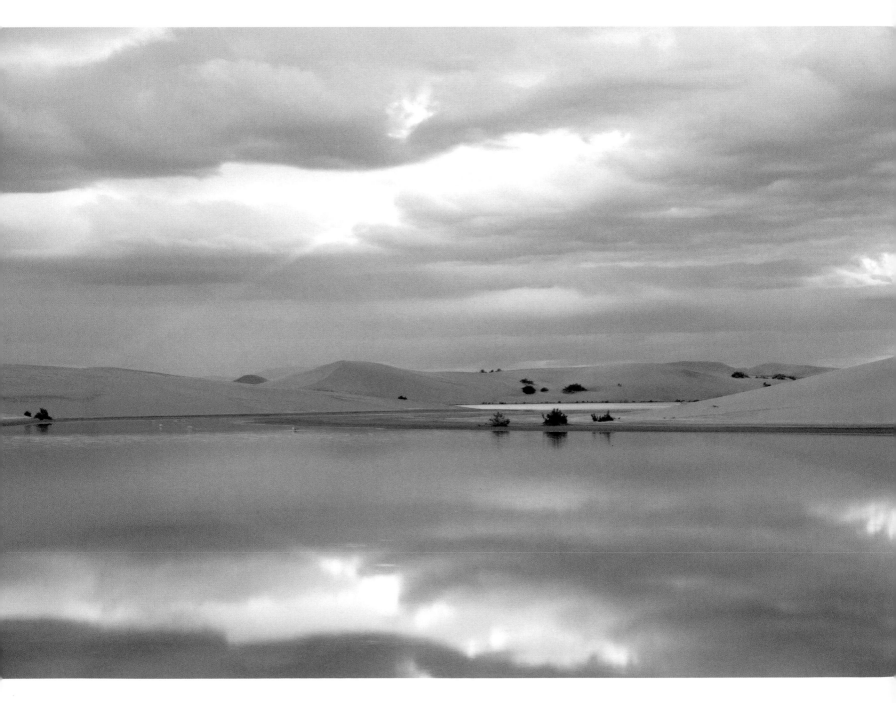

Introduction

There are some places we go not only to rest, or to slow the march of time, or to contemplate the power of nature, but to make a pilgrimage into one's self. Pilgrimages are Proustian madeleines of the soul, reminders that in the doldrums of day-to-day living we can journey to other places, other states of mind, where we can connect with and contemplate the essence of nature, spirit, and human civilization.

Often, we intentionally seek natural places of overwhelming grandeur, of Brobdingnagian proportions, in order to restore our inner sense of perspective. Because in that transient reduction of our own significance, dwarfed by the near-infinitude and formidable creations of geological time, we, as mere Lilliputians against the cosmic trelliswork at large, can better accept—with less pain, perhaps—the blackened never-never land that awaits all of us at the end of that self-extinguishing pilgrimage also known as life. Religious pilgrimages also are intended to bring humans in contact with the divine, offering a similar release into smallness.

Curiously, there is sweetness in the sorrow that attends these meditations, namely, that we can take solace in the fact that nature's magnificence will endure just fine without us. In a sense, the traveler hopes to return from the trek with just such a recollection, embodied in the touching of ancient stones, the witnessing of a sunset from the farthest spit of land—to experience a sense of forever, to step beyond the reach of history and outside the perimeter of human time itself.

Although, over the years, we have traveled to some of the planet's most magnificent sites, it was at the Central Javanese resort of Amanjiwo, a limestone monument to spirituality, rest, meditation, and simple pleasures, that we first learned to what degree a place can control our spirits. There, it was not only the ancient dances beckoning ancestral currents that put us in a trance; not only the early morning sunlight washing over the Buddhist monument of Borobudur just a stone's throw away—where we were compelled to contemplate the interconnectedness of all things; but the outwardly serene Javanese farmers who, as they have for centuries, pampered,

Battleground Point ☩ Lahontan Valley Wetlands, Nevada

sang in, and stroked their fields with the passion and devotion of a mother tending her child. Like two hands united in prayer across the landscape, Amanjiwo and Borobudur come together as two parts of a unified whole, each reflecting the high point of its respective culture, each needing the other to complete the trajectory from antiquity to the future. After only a few days, we began to think of our pilgrimage to Amanjiwo as a melody—formed from the frozen music of its stupas, silver-leafed dome, scorpion orchids, and limestone-skinned corridors—that echoes in the soul long after the instrument falls silent.

Like so many other pilgrimage sites, the ruins of ancient civilizations have a way of stimulating the neuronal jungle, opening up one part of the brain to another, thereby unleashing a cascade of vivid memories and associations previously hidden beneath the threshold of consciousness. There are some places that bring you to an understanding deeper than anything you've ever known—in a burst of unexpected clarity that is often called grace—that every living thing around you strives unquestioningly, joyously, to be what it is meant to be. In the spell of such places, there is no need to think and analyze, hesitate and

argue, deny and challenge, or question the path. The place shows the way. You follow. You don't even try to put it into words. Rather, a numinous power touches you and sends a current of healing through your bones. Call it a sanctuary. Call it the power of place.

This is a book of such places, both natural and ancient-cum-architectural, where people have found answers to questions they never even knew they had and whose experiences reverberated long after contact, like a subtle vibration of the soul. These spots have the power to make us weep with the joy of life and with the grief that comes from the realization that the instant is all there is: that each meeting is but a prelude to departure, each acquisition already a loss, each birth just death in the making.

Photographs, especially, play a pivotal role in the way we visualize and project our escapes, and where we choose to take them. It may be the wonderous hourglass-fine sand of Thailand, a view of Mt. Hood, the power of Victoria Falls, the burnt red of the Arizona desert, or a Japanese garden. No matter what the tableau, each is an explicit invitation to plot an imaginary—or actual—journey to a place that has the power to be a spiritual anodyne. Seen through the eyes of photographers

who have made it their life's goal to find and chronicle such spaces, these images have the power to distill the essence of a place—an essence in which the ecstatic engagement with gardens, shrines, or landscapes is derived from their capacity to infect the viewer with their vital peace and to inspire a profound love for the beauty and wisdom of the planet that make everything else seem insignificant.

This portfolio of photographs is devoted to the proposition that there is a supreme regenerative, uplifting, and restorative power in beautiful images of sites imbued with an irrefutable, sacred calm: the crumbling ruins of Greek temples, an Edenic island beach, a muted desert landscape in Morocco, a rock garden on a windswept bluff, a spiral pool in the Columbia River Gorge, the ancient sculptured heads of the South Pacific, fields of wildflowers in an Alpine meadow, a rainbow over Southwest National Park in Tasmania, a wooden boat adrift in a placid lake, the dramatic beauty of Granite Arch and Lone Pine Park, a never-ending torrential cascade of water over a precipitous cliff, zones of cosmic convergence where mysterious energy fields cross and crisscross—Stonehenge, Carnac, Ayers Rock.

Other sacred sites are more overtly religious and have been subject to human scrutiny for millennia. The three preeminent pilgrimage destinations of the Middle Ages were Rome, Jerusalem, and Santiago de Compostela. From the eleventh through the eighteenth centuries, devout Christian pilgrims streamed from all parts of Europe across ancient pathways and byways that overlay pre-Christian tracks—the trails of mysterious worshipers in a mysterious landscape of menhirs, banished gods, and forgotten cults—to stand, in awe, before the sacred remains and signs of a manifest God.

Armed with prescribed costumes and attitudes—the blessed staff, a cloak, wallet, and a broad hat to fit over a head filled with instructions from the Codex Calixtinus, the twelfth-century guidebook—the penitents set out, confident that their trappings, as much as their prayers, would keep them safe from robbers and bandits, and would secure them food and shelter along the arduous journey. Along the way, they were ministered to by institutionalized medieval charity in the form of relay stations and hostels, manned by various chivalric orders—Templars, Hospitallers, and others—that were the precursors of modern hoteliers.

The modern tourist and the medieval pilgrim also share at least one belief in common: that certain places and objects are endowed with a mysterious power that makes one a better person for having visited them. How this works was certainly clearer to the theologian and the believer of the Middle Ages than it is to us: they explained it by the workings of divine grace. Ask, and you shall receive. Better yet: Go directly to the source, and ask again. The source in question could be anything: a spot of ground trod by Christ; a bit of bone from the thigh of a holy nun; a mineral spring. What mattered was that the spot be reputed to transport the mendicant to the threshold of the divine. Today's traveler could be said to be looking for something as sublime but more subjective and ethereal: landscapes of the soul.

In selecting images for this book, we looked for the perfect melding of setting and photographer's eye—searching for the best images from the most talented, sensitive photographers in the world—to generate the inspirational qualities that take readers on a journey outside the frenzy of modern urban life.

The photographs expand on the notion of the "Seven Wonders of the World" by showing over one hundred "Wonders of the Planet." Connected by minimal text blocks that function like the "ley lines" or sacred paths of Stone Age humans, the images serve as visual morphine for the soul—better living through the chemistry of Kodak, Fujichrome, and Ilford—with the capacity to soothe the spirit, to project a sense of immutable, infinite peace.

The fourteenth-century pilgrims returned from their transformational journeys to sacred sites such as Santiago de Compostela with a scallop shell and a *Compostela,* or certificate of arrival, that bore tangible testimony to their life-altering experiences. Modern pilgrims, who journey out of love for nature, out of fear, and out of a drive toward self-improvement— spiritual and physical—return home with souvenirs and photographic albums of images that attest to their regenerative experiences. This volume is offered to the armchair traveler and to the sedentary pilgrim as both an itinerary into and as a testimonial to the power of this planet's beauty and of the human spirit vulnerable to its spell.

—Gideon Bosker and Lena Lenček

Iceberg Arch ÷ Ilulissat, Greenland

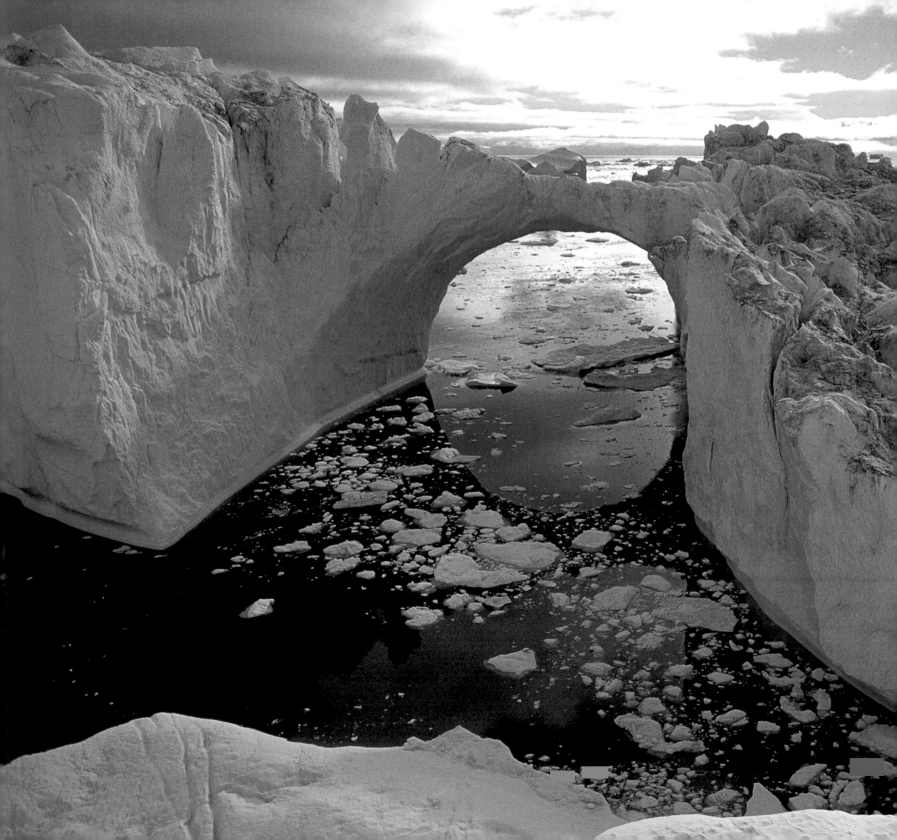

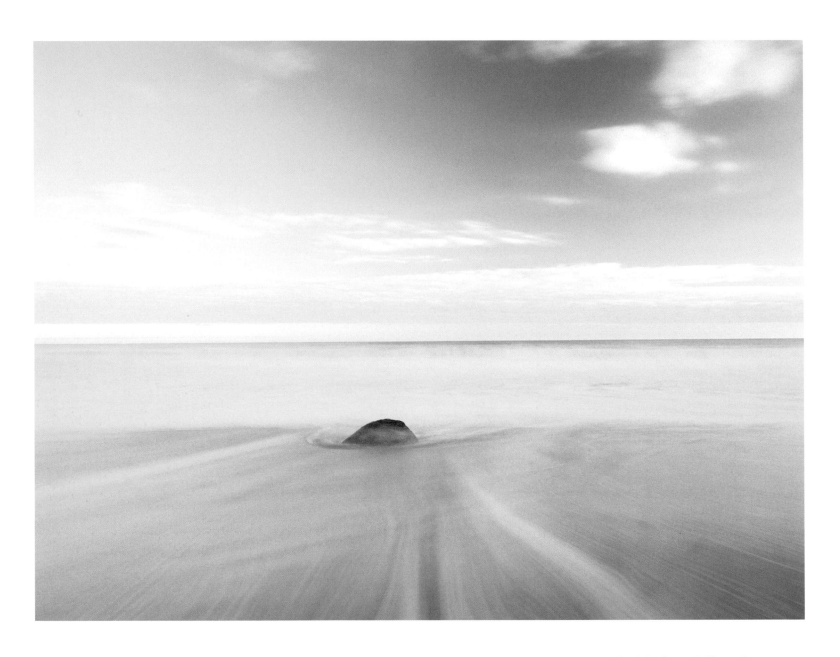

Lucy Vincent Beach ✣ Martha's Vineyard, Massachusetts

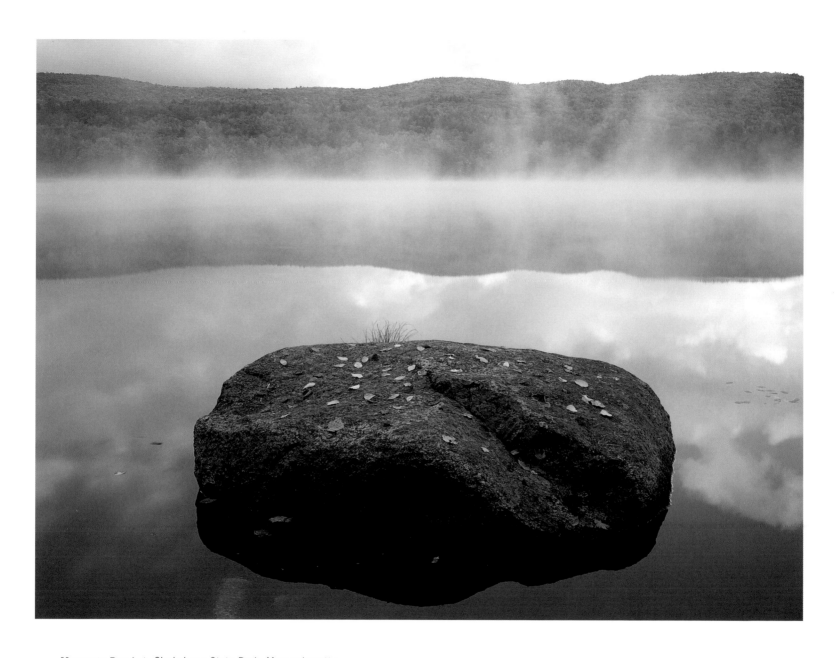

Mauserts Pond ÷ Clarksburg State Park, Massachusetts

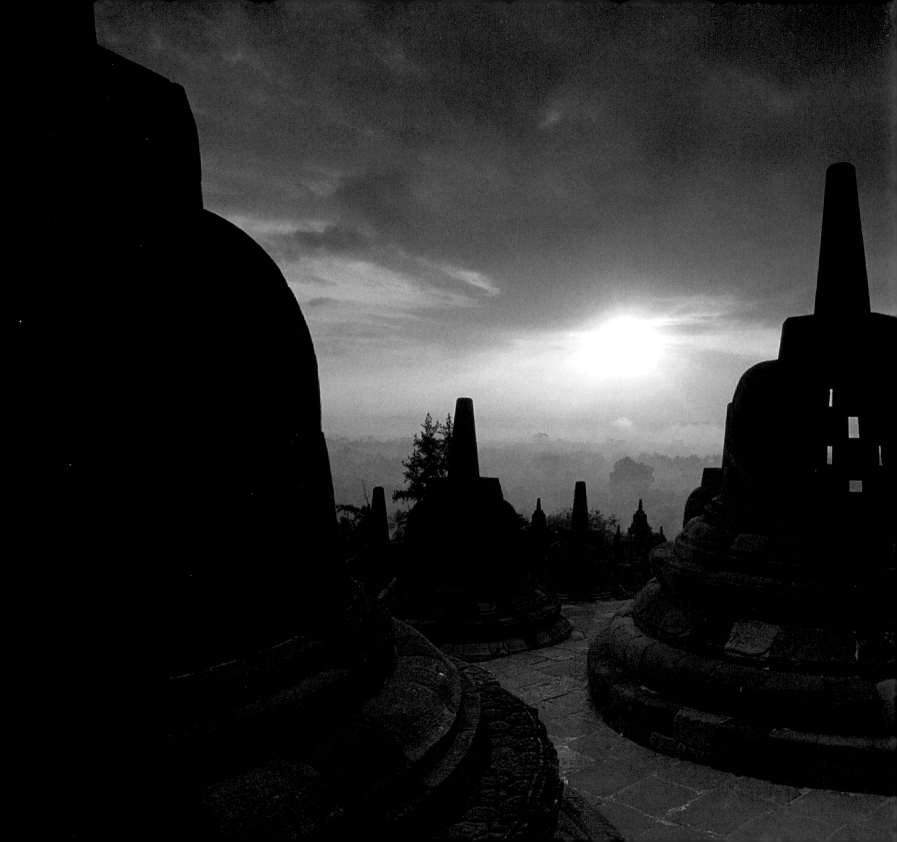

Mysterious in its origin, Borobudur—or the "Temple of the Countless Buddhas"—is an allegorical reenactment of man's progress to nirvana through successive stages of spiritual enlightenment. Five progressively smaller, steeper terraces symbolize worldly desire, malevolence, malicious joy, indolence, and doubt. These culminate in three circular platforms crowned with 432 stupas, or bell-shaped domes, containing life-sized statues of the praying Buddha. For the believer, the architecture both mimics and enacts the sacred circumambulation that leads to the apex, the world of formlessness, or *aruphadatu*, the realm beyond heaven where all form and identity dissolves. From this culminating point—as from the peak of enlightenment—the pilgrim can no longer see the stages of imperfection below. Even for the nonbeliever, greeting the rising sun from this topmost realm is an incomparably peaceful experience.

Sunrise at Borobudur ✛ Java, Indonesia

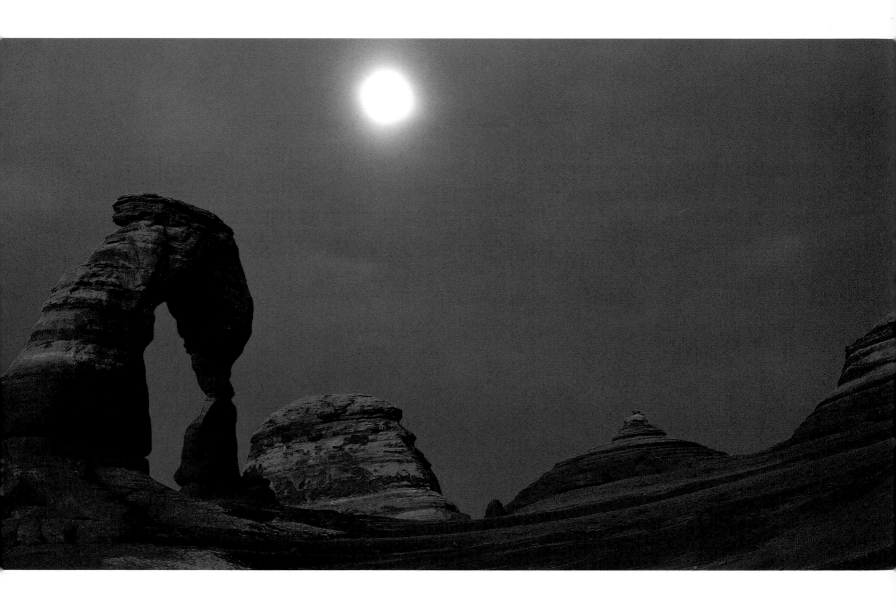

Delicate Arch ✢ Arches National Park, Utah

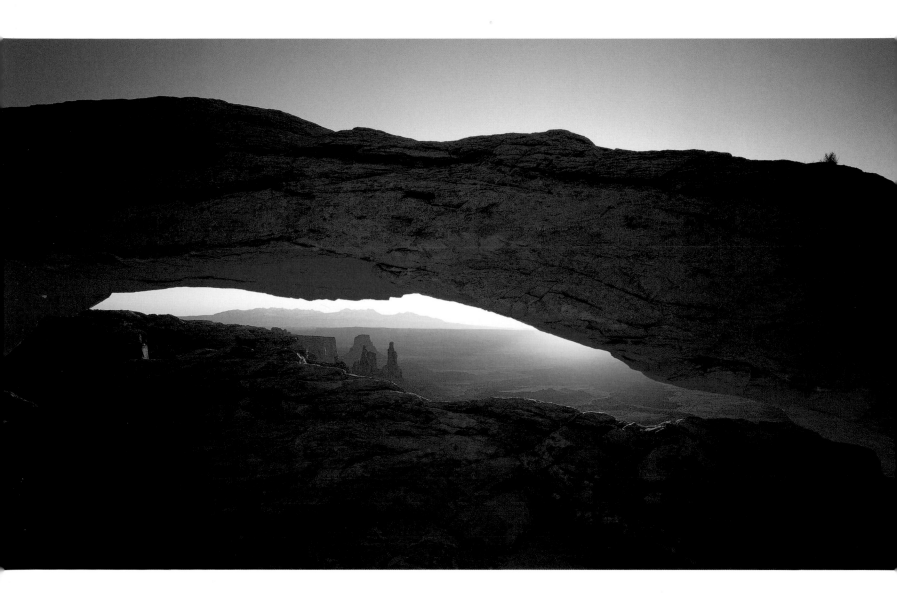

Mesa Arch ✢ Canyonlands National Park, Utah

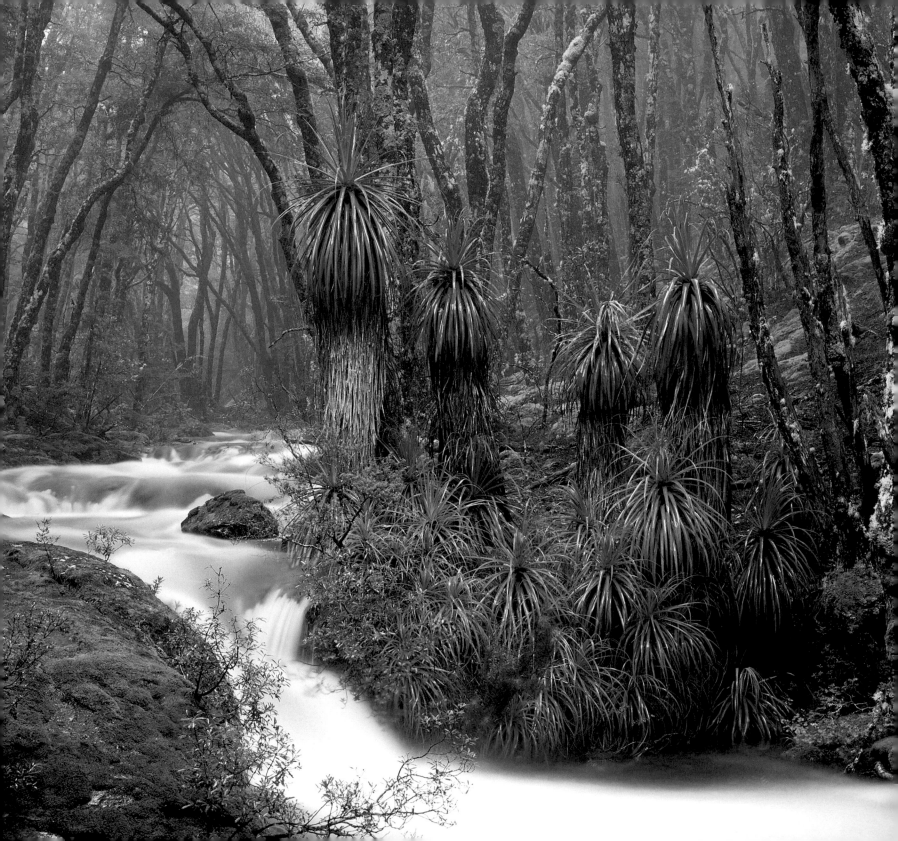

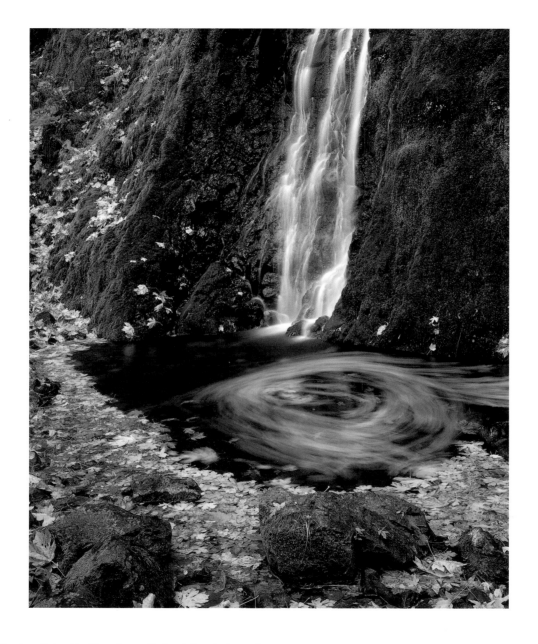

Spiral Pool ✛ Columbia River Gorge National Scenic Area, Oregon

Rainforest Stream in Mist ✛ Tasmania

. . . If ever you have come upon a grove that is full of ancient trees which have grown to an unusual height, shutting out a view of the sky by a veil of pleached and intertwining branches, then the loftiness of the forest, the seclusion of the spot, and your marvel at the thick unbroken shade in the midst of the open spaces, will prove to you the presence of deity.

— Lucius Annaeus Seneca
Epistle XLL, *On the God Within Us* (excerpt)

Wild Rhododendrons ⁘ Table Rock Wilderness, Oregon

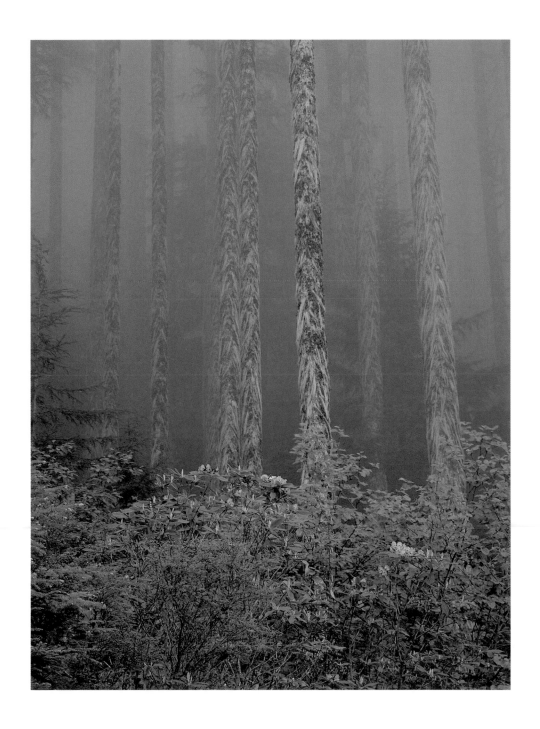

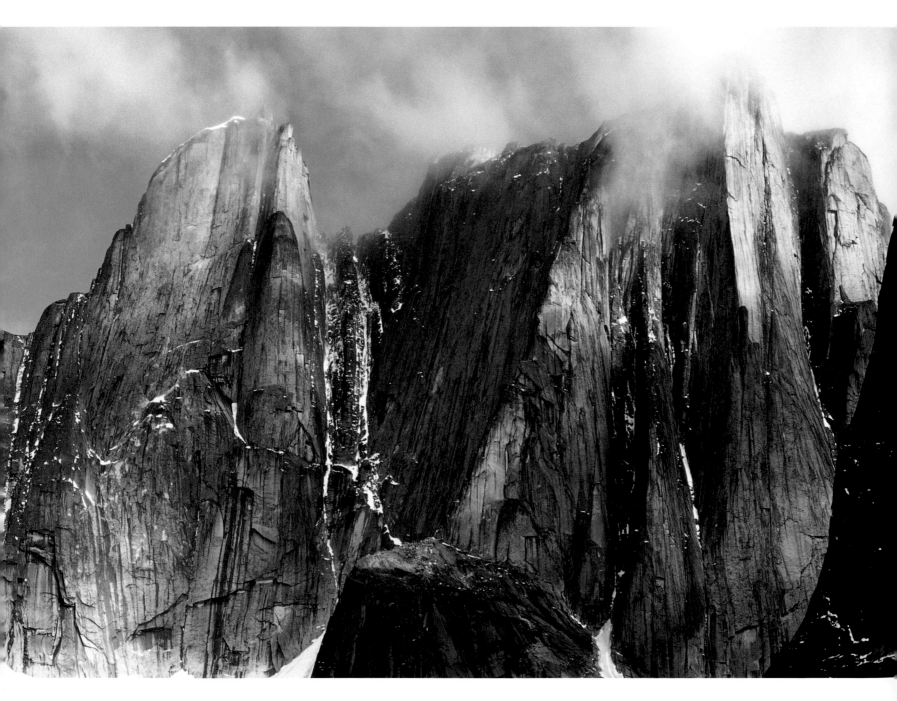

Thrust up by the tremendous force of colliding tectonic plates, the massive ranges of the Northwest Territories sit on the greatest fracture of the North American continent. Summits of awe-inspiring size and fearsome ruggedness, their height and grandeur have contributed to their being viewed as sacred. Among the Koyukon and the Tlingit, the indigenous peoples living in their midst, this majesty demands a special protocol of address summed up in the admonishment, "Don't talk; your mouth is small." From childhood, the Koyukon are taught to show respect to the mountains by not talking about their size while looking at them.

Rugged Peaks ⊹ Northwest Territories, Canada

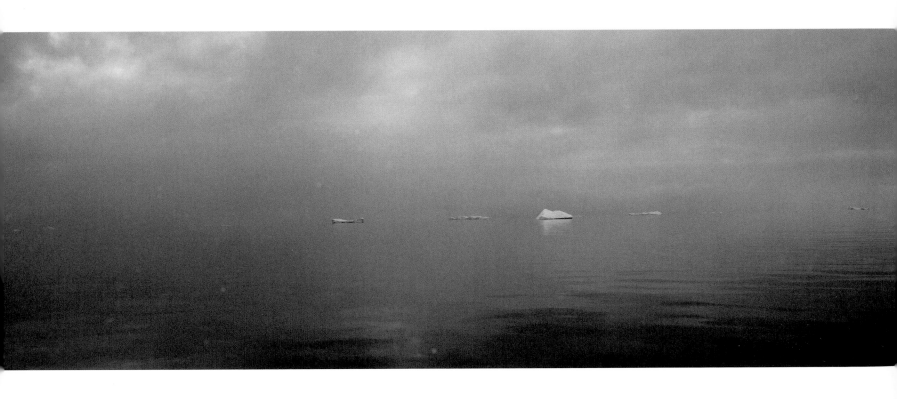

Icepack ÷ Greenland

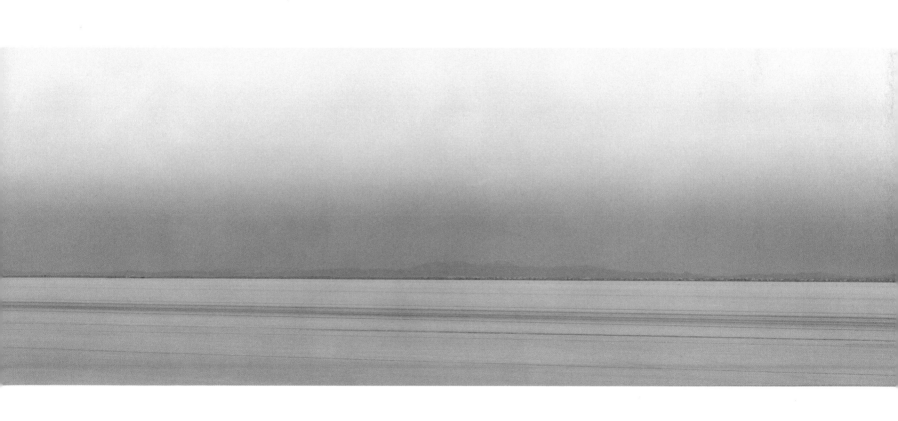

Bonneville Salt Flats ⊹ Utah

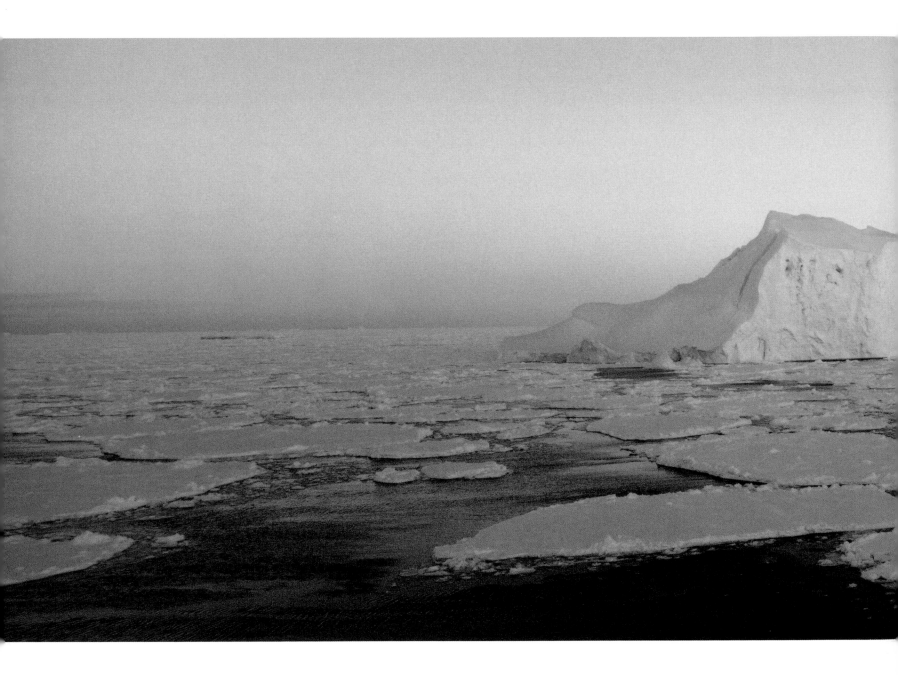

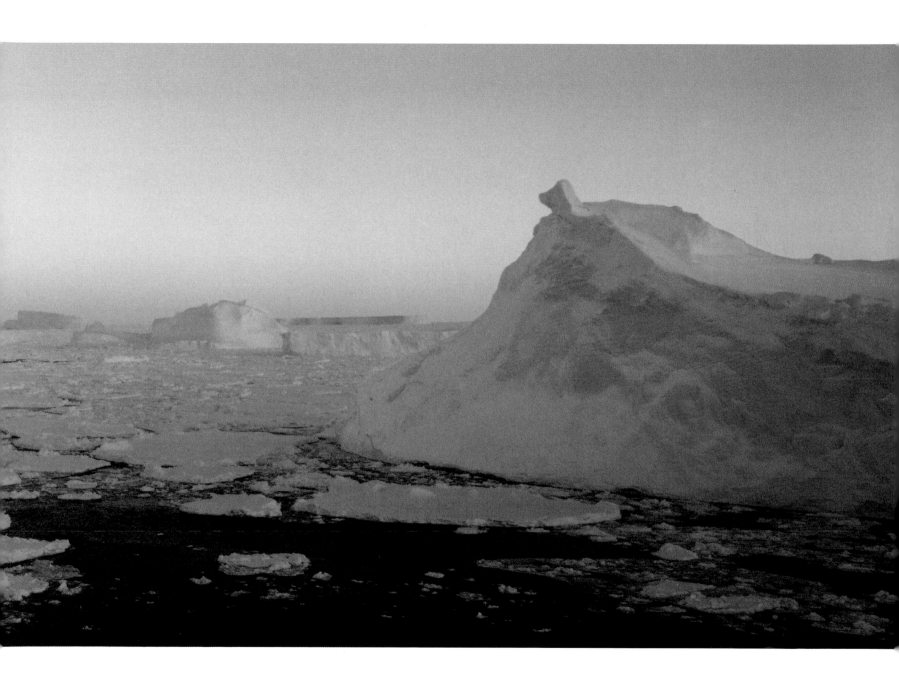

Ice Floes, Pink Sky ✣ Antarctica

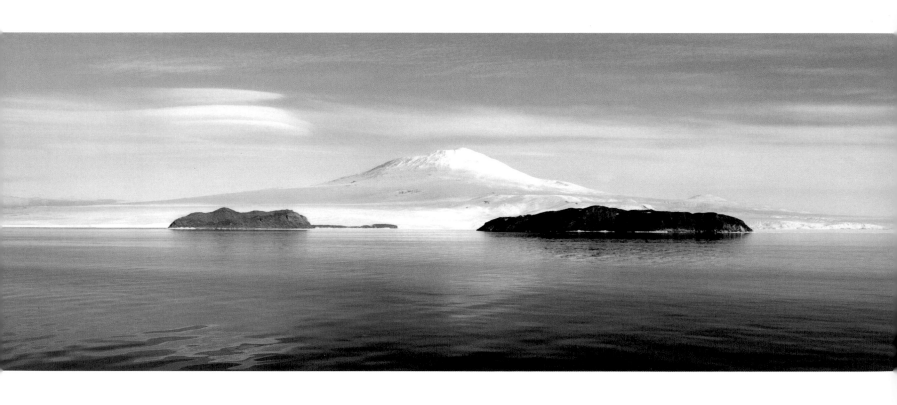

Icebergs debouche from a glacier bay. Formidable hunks of dense, blue-white ice float calmly on thick water. Some look like Tiffany glass, others like ears of corn. Seen through human eyes, the hulking masses take on the shape of giant molars, titanic flamingos, tractor-tire treads in the snow, but bear no traces of human passage: a thousand miles of harsh, wild beauty, governed by the movement of ocean, the flux of weather, the interplay of air, water, ice, fog. From the depths of the ice issues a constant concerto of clicking, cracking, moaning, and booming as the glacial masses expand and contract, rupture and collide, in response to the fluctuating temperatures and tides.

Ice Floes, Blue Water ÷ Antarctica

Pilgrimage site for intrepid rock climbers, the brick-red monoliths of Utah's Fisher Towers jut abruptly from the desert floor. Eons of geologic abuse, of winds and driving rains, have sculpted the soft red sandstone into silhouettes evocative of ceremonially robed titans, spellbound by the rising moon crossing the horizon. The sweetest, magical moment of the day comes about half an hour before sunset, when the oblique rays of the sun animate the pitted, creased, striated columns. The air becomes strangely resonant and carries the whisper of breath for what seems to be miles. After hours of baking in the naked glare of the sun, the steep flanks of rock are the color of an angry sunburn and the warmth of living flesh.

Moon Rising ⋕ Fisher Towers, Utah

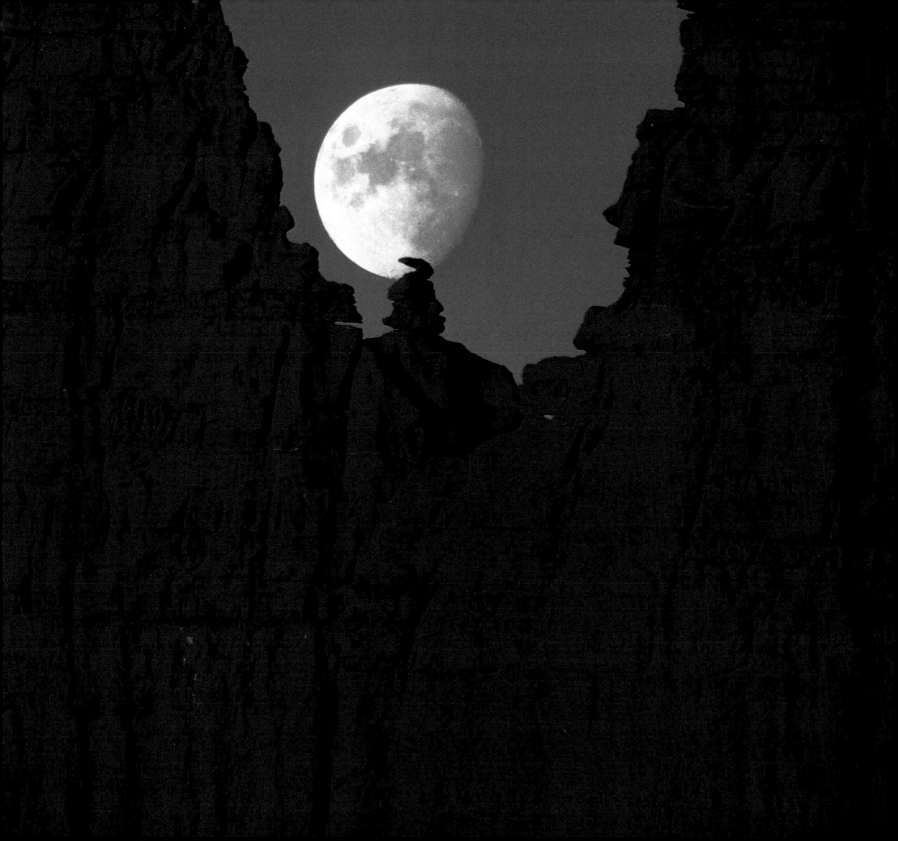

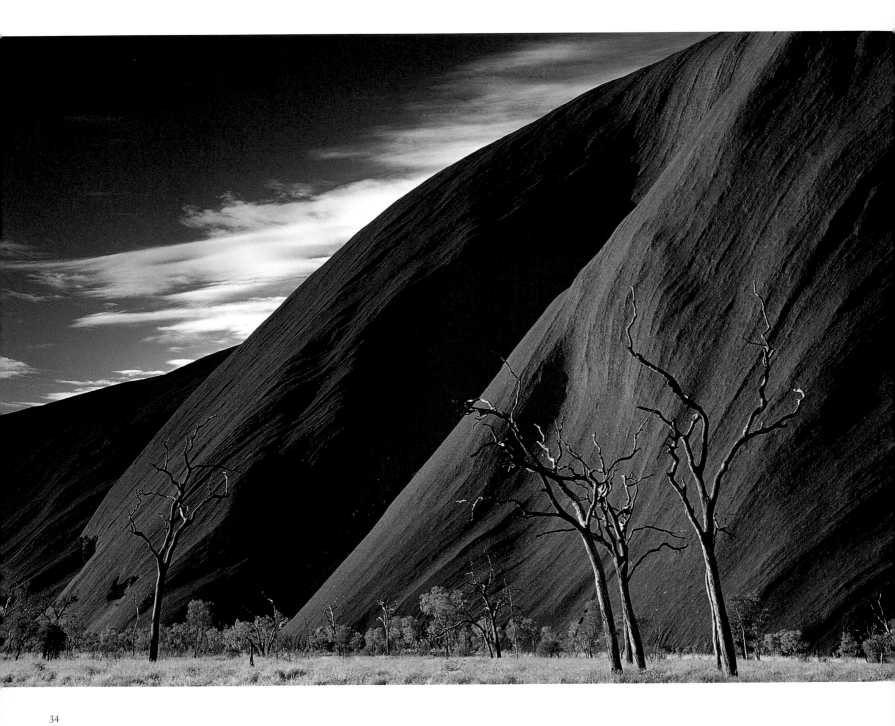

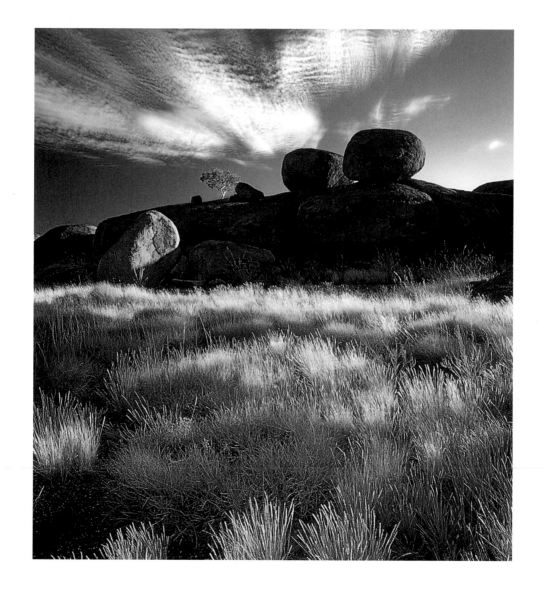

Devil's Marbles ✣ Northern Territory, Australia

Ayers Rock ✣ Uluru National Park, Northern Territory, Australia

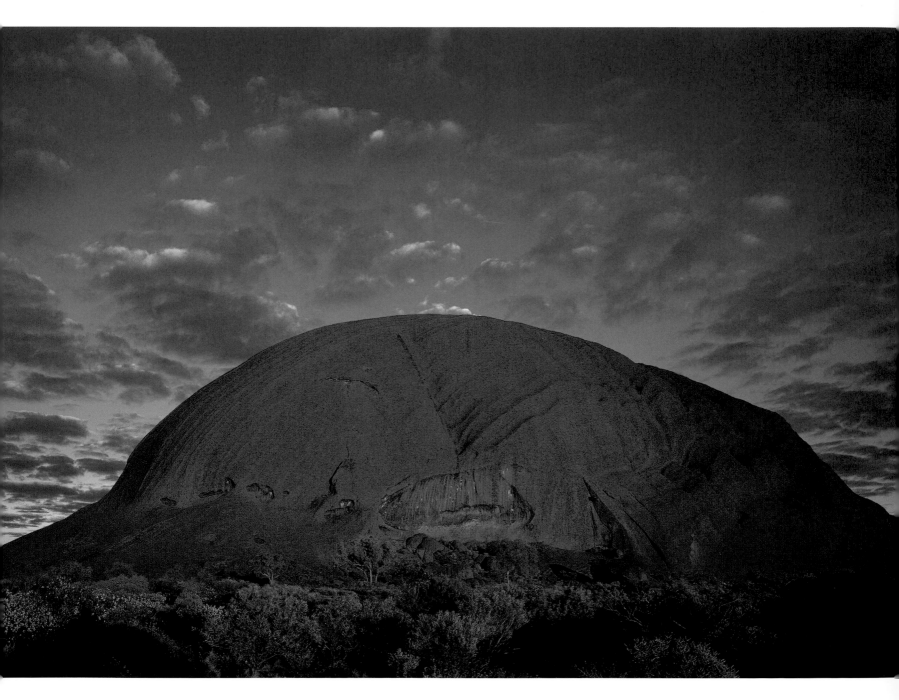

Long before the eleventh-century believer pilgrimed to Santiago de Compostela, the Aborigines of Australia roamed the countryside in rituals they called "walkabouts." In songs the Aborigines told of a distant, dimly recalled Dream Time, when ancestral beings and *kurunba*, spirits of place, issued from the depths of the earth. As they roamed the land, they fell in love, played and sang, bore children and died, and from their loving and their hunting, their games and their songs, they brought forth hills, trees, boulders, caves, lakes. When the dreamtime of the spirits ended, the marks that they had left upon the earth hardened and became sacred sites, joined by paths that followed dreaming tracks, or song lines, along which countless generations later trod to regenerate the spirits of the living earth for their own benefit or that of the tribe and for the health of the surrounding land. Uluru, or Ayers Rock, stands at the point of intersection of dozens of these dreaming tracks. Bubbling out of the desert plain like a gigantic, fiery belly, the arkose rock appears, at various times of the year, to emit a mysterious light, continually bringing forth the energy that has sustained and renewed the land of the Aborigines for more than forty thousand years.

Ayers Rock ✜ Uluru National Park, Northern Territory, Australia

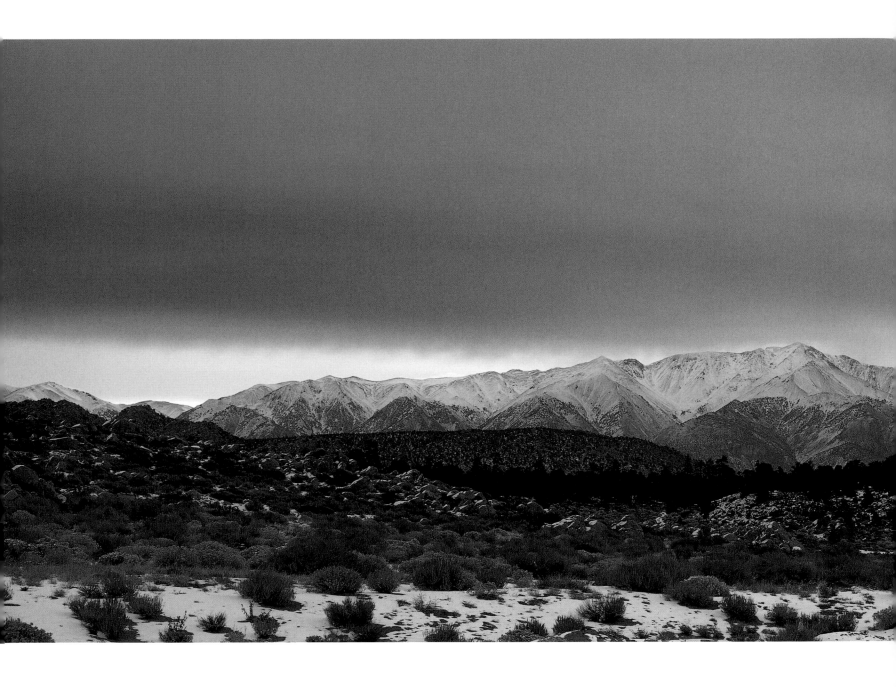

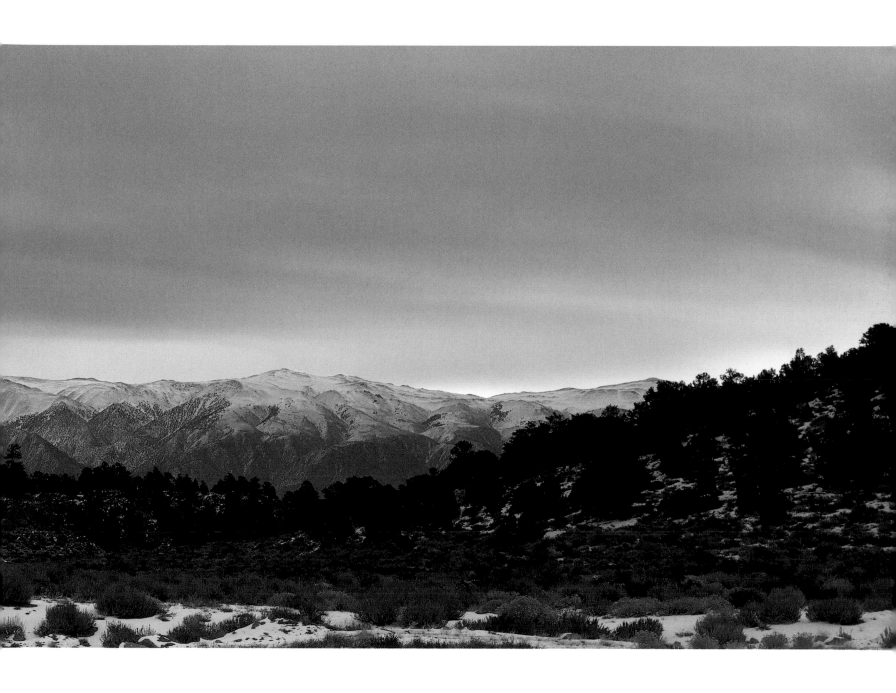

Winter Sunrise ÷ White Mountains, California

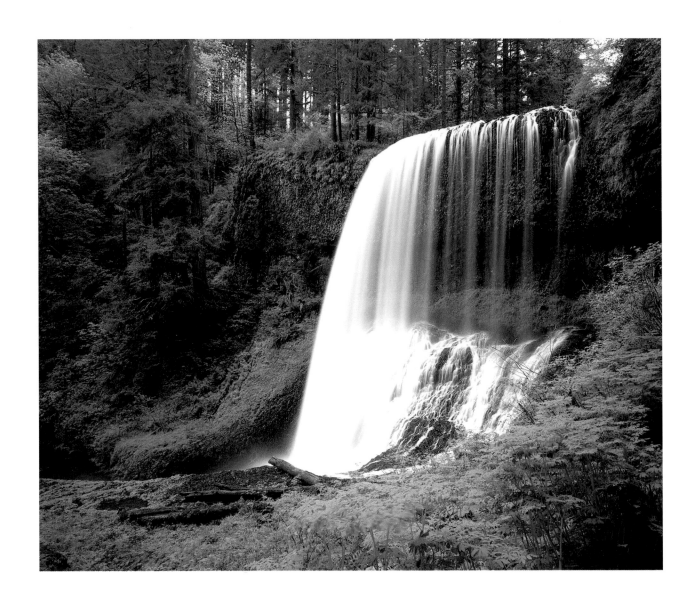

North Middle Falls ⁜ Silver Falls State Park, Oregon

Wildflowers ⁜ Mt. Rainier, Washington

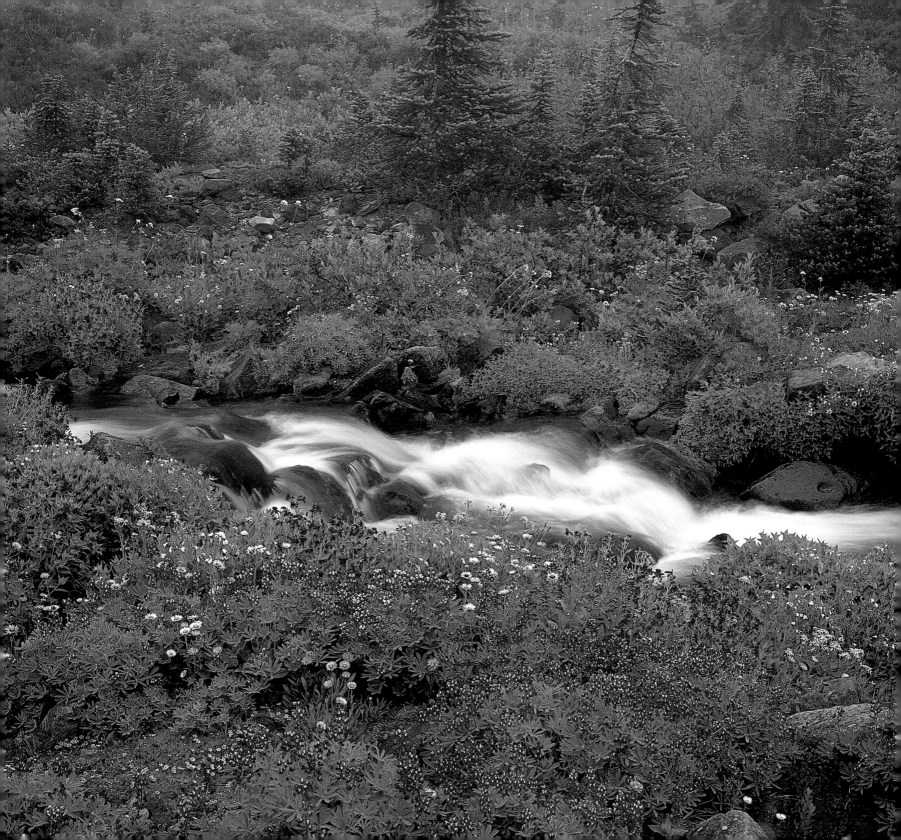

The *Sakuteki,* the oldest surviving Japanese garden manual, correlates the creation of gardens with the placing of stones. In Shinto belief, stones are regarded as *iwakura*, or abodes of deities, and are objects of veneration. In spiritual rock gardens, both the shape and the placement of stones are carefully premeditated to symbolically suggest the spiritual fundament of the world, and to induce spiritual harmony and a sense of balance. The two most auspicious forms include a tall, mountain-shaped stone, often used as a centerpiece (*omo ishi*) in a grouping of lower stones, and a low, flat-topped stone. According to the *Sakuteki,* "setting stones"—*ishi wo taten koto,* the simple act of setting a stone upright in a cleared space—was ascribed a powerful spiritual and aesthetic function. Because the natural world was taken as the model of balance, propriety, and healthfulness, gardens were expected to replicate the inherent patterns of nature. A garden was designed to introduce the innate balance of the uncultivated landscape into the domestic sphere and thus to harmonize one's everyday life with the rhythms of the cosmos. To deviate from the natural order—by standing stones upside down, for instance, or by redirecting the natural flow of water—threatened to disrupt both the aesthetic and the spiritual integrity of the home. On this topic, the *Saketuki* warns, "Regarding the placement of stones there are many taboos. If so much as one of these taboos is violated, the master of the household will fall ill and eventually die, his land will fall into desolation and become the abode of devils."

Japanese Garden ✦ Portland, Oregon

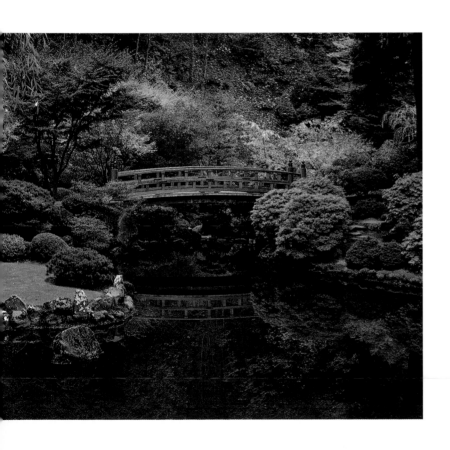

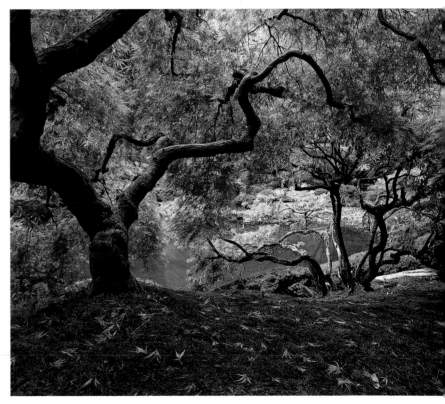

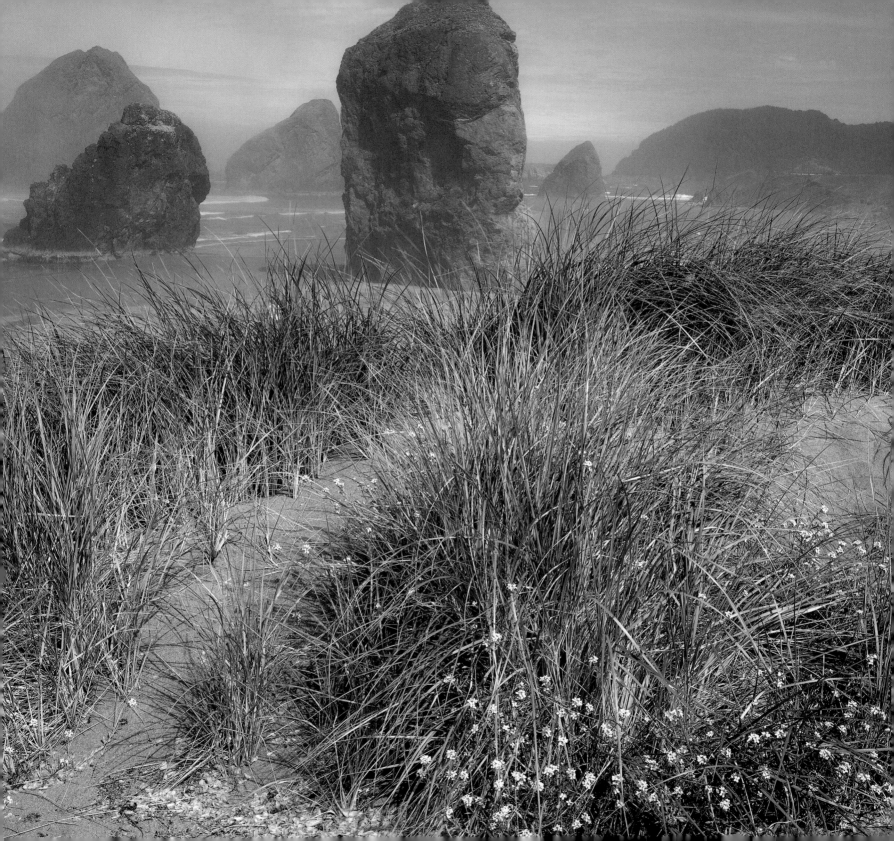

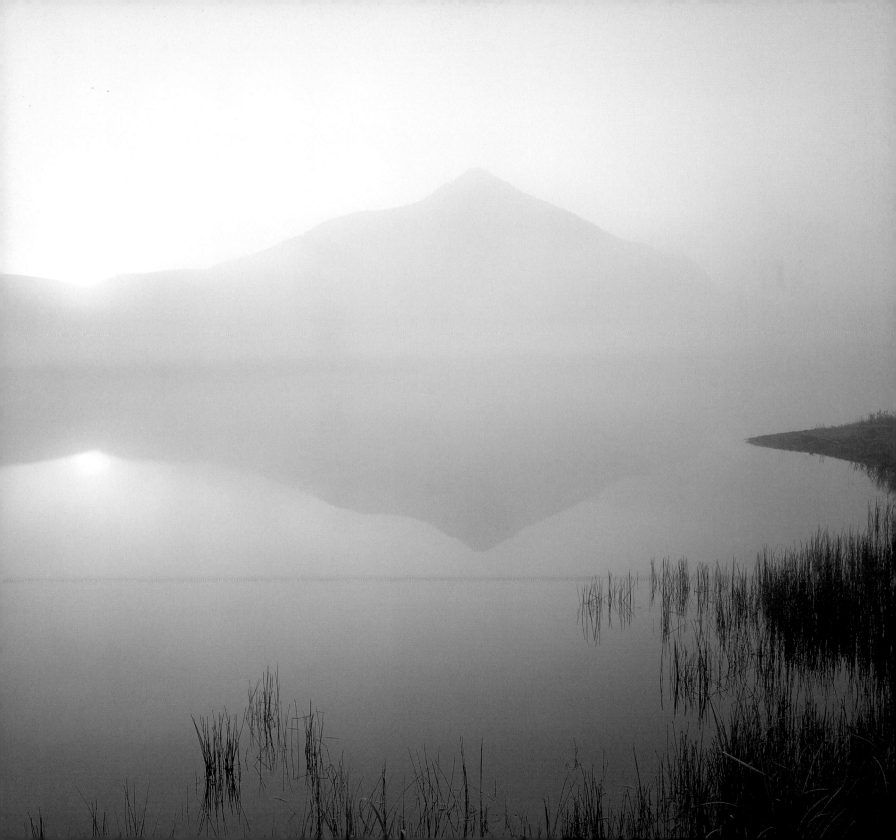

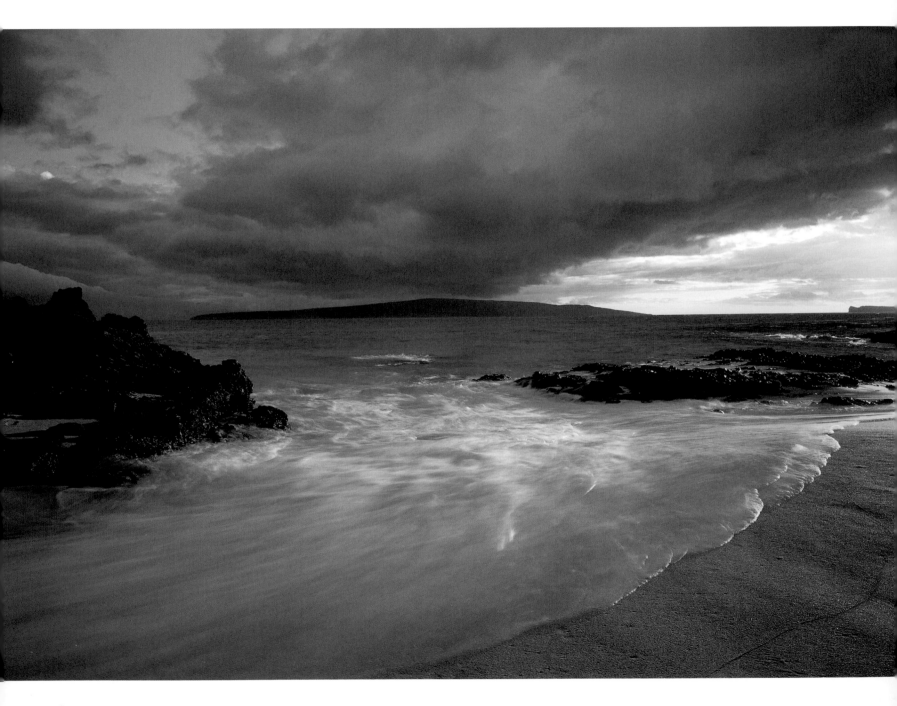

For centuries, European artists have drawn inspiration from the sky, reading allegorical meanings and allusions in its inexhaustible expanse, its endless play of color, light, and shape. But for nineteenth-century Romantics, the empyrean realm took on a near-religious importance, symbolizing pure spirit, creative genius, and endless flights of imaginative fancy. "Grand masses of dreamy forms floating by each other," wrote the Hudson River School painter Jasper Cropsey in the 1860s, "sometimes looking like magic palaces, rising higher and higher, and then toppling over in deep valleys, to rise again in ridges like snowy mountains, with lights and shadows playing amongst them, as though it were a spirit world of its own."

Makena Coastline ⌖ Maui, Hawaii

previous pages, left: **Morning Fog** ⌖ Cape Sebastian, Oregon Coast

previous pages, right: **Peanut Lake, Sunrise** ⌖ Gunnison County, Colorado

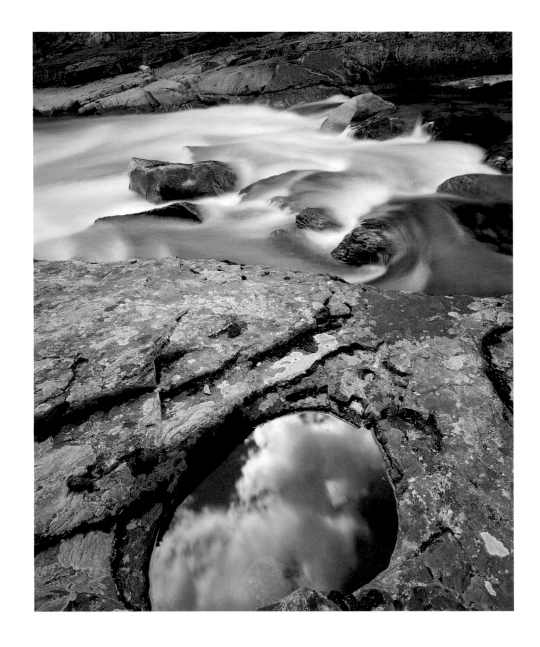

McDonald Creek ÷ Glacier National Park, Montana

Ice Sculpture ÷ Glacier Bay National Park, Alaska

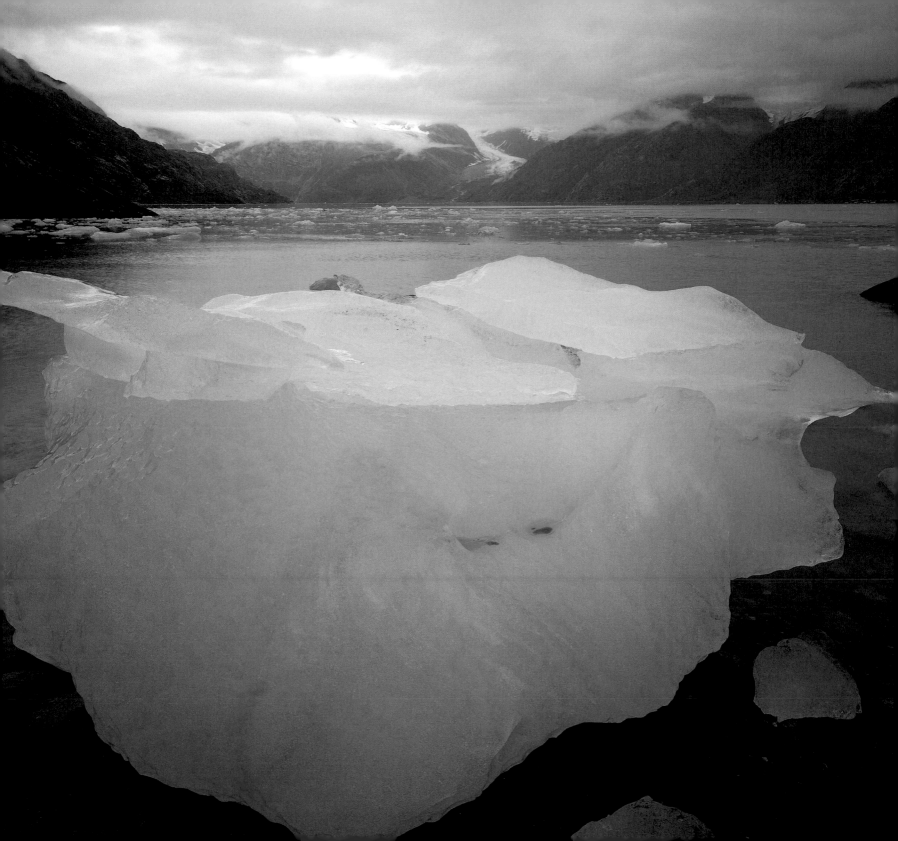

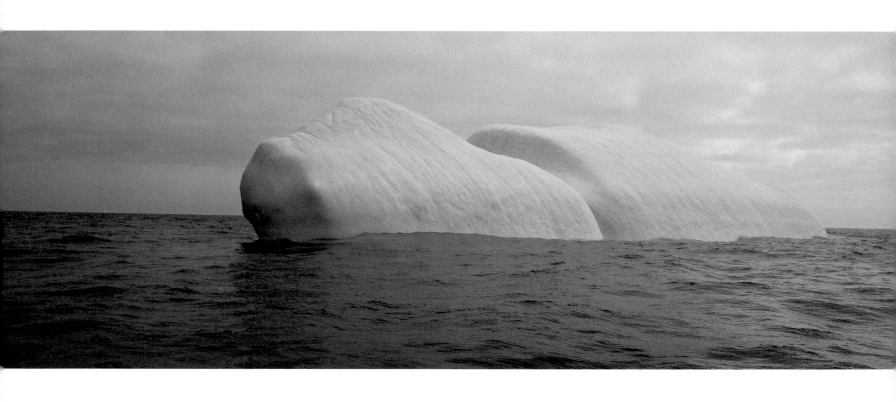

Glacier, Gray Water ÷ Greenland

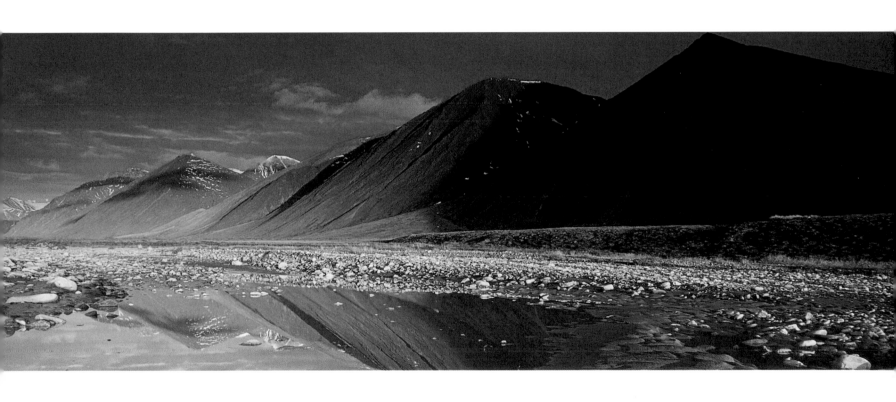

Upper Jago River ÷ Artic National Wilderness Refuge, Alaska

A mysterious power or energy appears to give certain locales the ability to heal the body, enlighten the mind, stimulate creativity, trigger psychic awareness, and catalyze mystical insights. Comparable to invisible magnetic forces, such energy fields occur in nearly every setting: caves, forested glens, mineral springs, mountains, deserts, and canyons. Yet for all their variability, sites with powerful energy fields seem to share a constant set of features. Typically, they are located on or near geological fault zones, in areas of tectonic volatility that are distinguished by anomalous geophysical activity, such as unusual levels of radioactivity, exceptional seismic or volcanic action, the presence of magnetism, or high concentrations of mineral ores. Not surprisingly, many of the world's most sacred temples and esoteric stone circles are sited within a mile of some sort of tectonic disruption or surface fault. Over the centuries, as the medicinal properties of such sites came to be recognized, the predominantly religious pilgrims who had traveled to them were gradually replaced by patients seeking cures and therapies for physical ailments. Some of the more intrepid have ranged as far afield as Lake Rotorua, a healing lake deep in the geothermal heart of New Zealand, where geysers, boiling mud pools, steaming craters, and spewing fumeroles belch malodorous sulfur fumes into the crystalline air.

North Island ∻ Rotorua, New Zealand

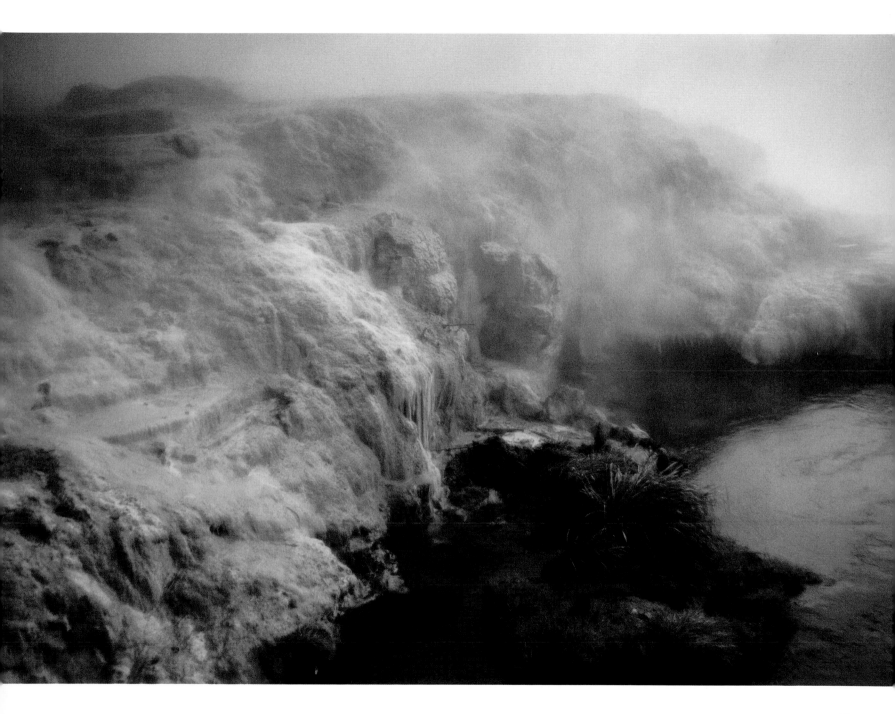

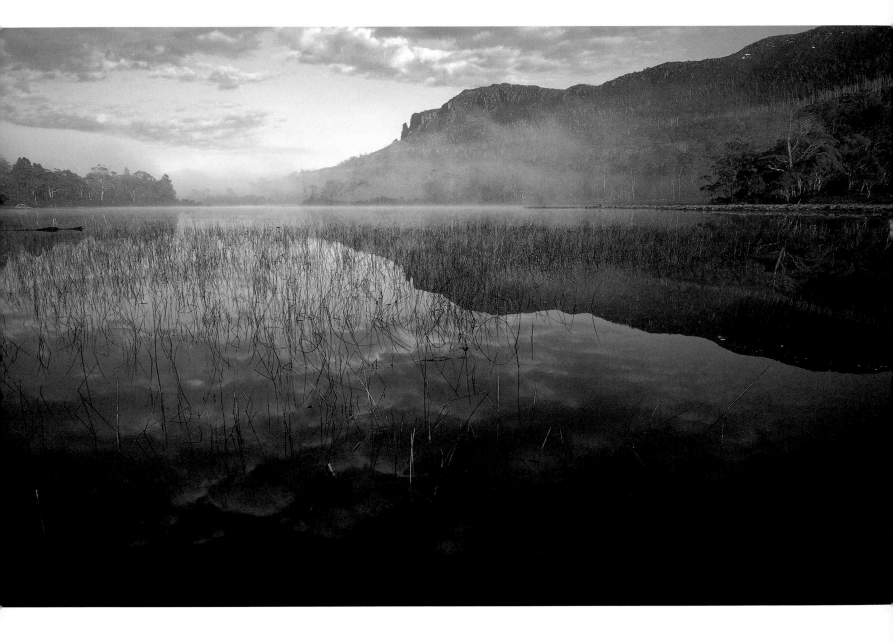

Highland Lake ✧ Cradle Mt. National Park, Australia

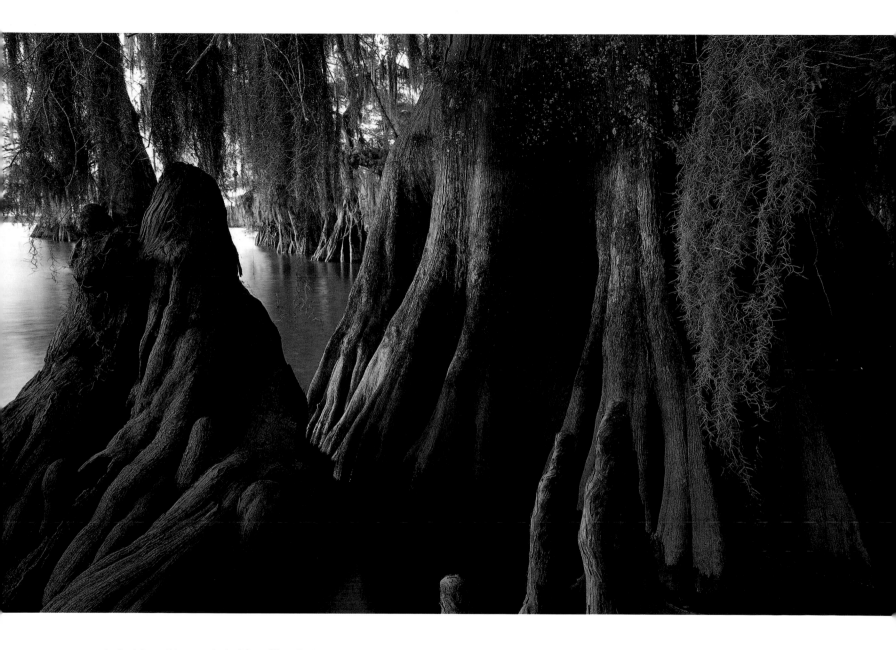

Atchafalaya River ✢ Atchafalaya River Basin, Louisiana

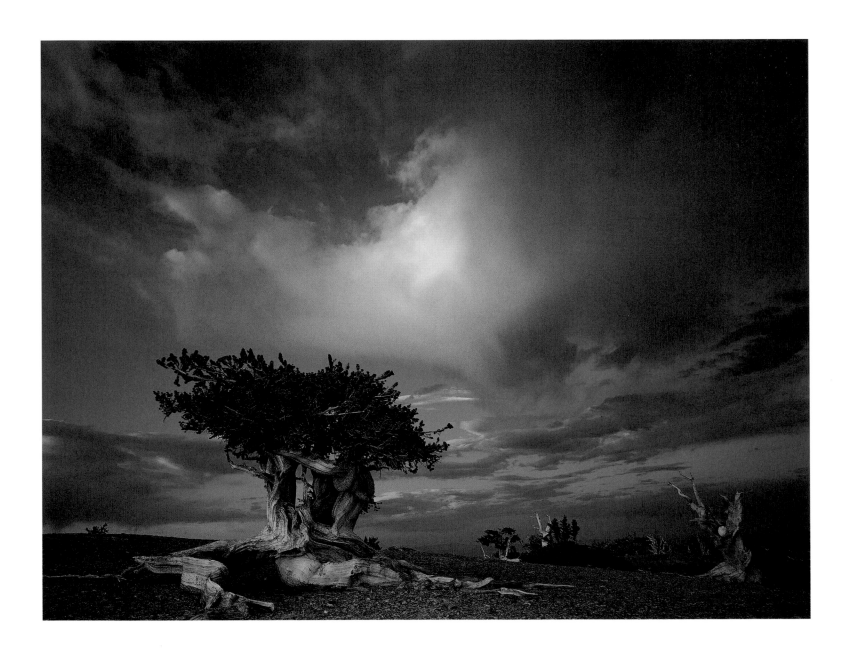

Bristlecone pines are among the oldest living things on earth. Some germinated over four thousand years ago, antedating the Tasmanian Huon pines by two thousand years. Miraculously, each spring coaxes fresh, young growth from aged limbs; each summer nurtures a new crop of fruit. The ancient Greeks imagined that the tree was an incarnate divinity, and greeted the death of a tree with grief and bereavement, as if a beloved and respected eminence had passed away. Thus, the *Homeric Hymn to Apollo* tells us, ". . . whenever fated death is near at hand, first these beautiful trees wither on their ground, and bark all around them shrivels up, the branches fall away, and their souls and those of the nymphs leave the light of the sun together."

Ancient Bristlecone Pines ✢ Great Basin National Park, Nevada

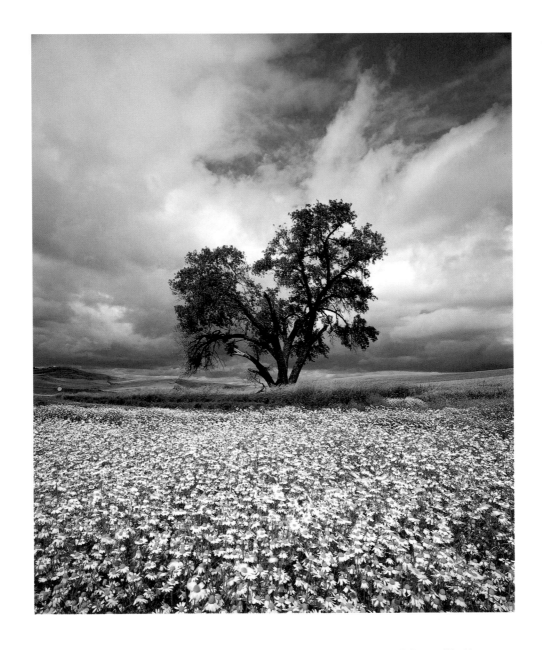

Oak Tree, Daisy Field ✣ Palouse, Washington

Flowers ✣ Painted Hills, Oregon

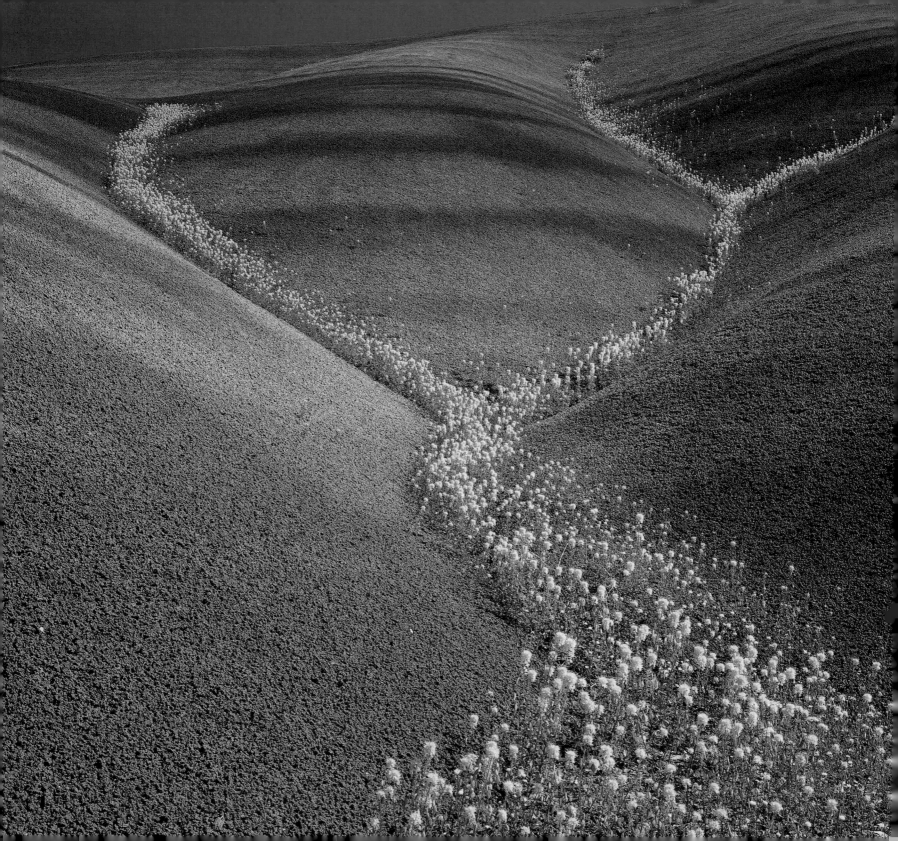

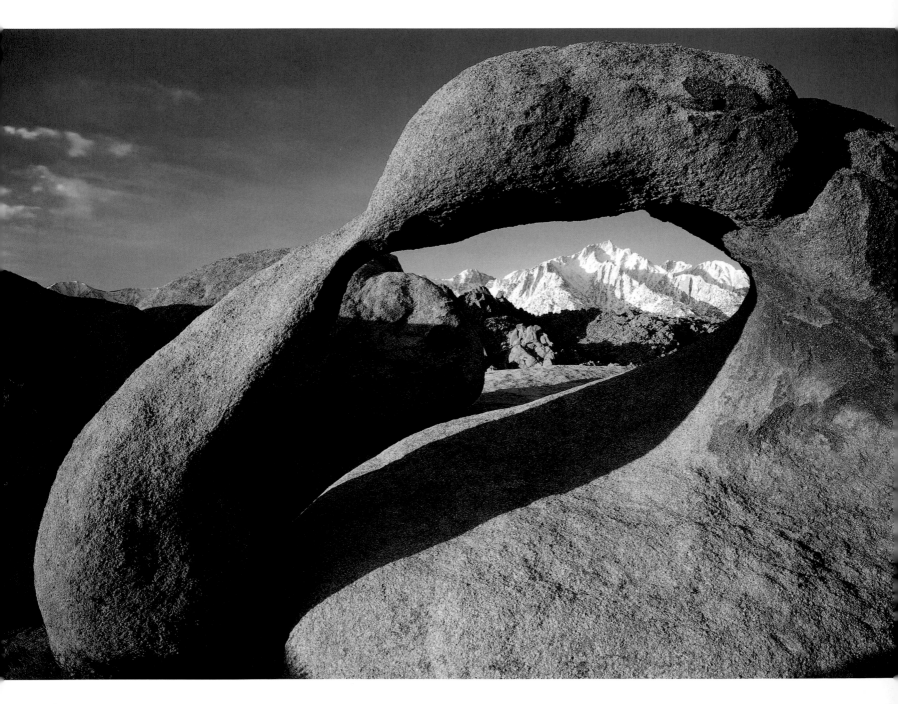

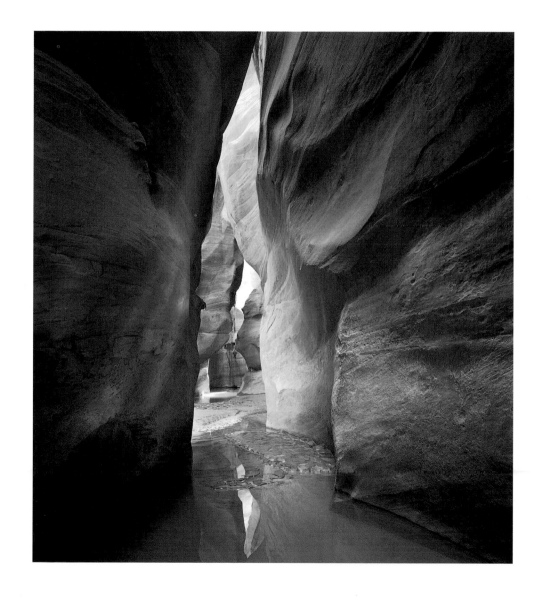

Sandstone Slot Canyon ✥ White Canyon, Utah

Granite Arch, Lone Pine Park ✥ Sierra Nevada Range, California

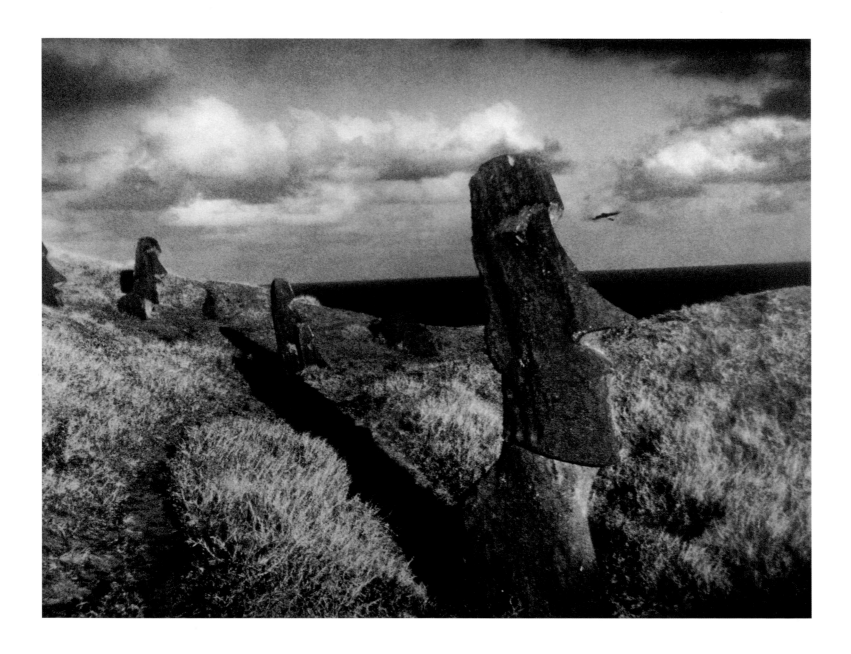

Te Pito o te Henua, variously translated as "Navel of the World" or "Land's End," is a triangle of volcanic rock in the southeastern Pacific, over two thousand miles from South America. At regular intervals along its green, volcanic slopes a thousand human heads loom out of the turf, their faces stern, their arms thin and tight against bulbous hips. *Moai,* ancestral idols carved with basalt hand-picks from volcanic tuff, the giant stone monoliths had once kept watch over their makers. Legend has it that Hotu Matau, the first man to reach the island, divided its coastline among six sons. Each of them erected a stone platform, an *ahu,* between the shore and his village, as protection against dangers coming from the sea. Then, in the crater wall of an extinct volcano, they carved images of dead chiefs, some two—some ten—times the height of a man. But the statues were too large to move. And they stayed, far from the dwellings of men, until one day, a chief endowed with great *mana* ordered the statues to walk. Hearing his words, the statues rose up and went, each to the place most convenient to him. Or, then again, maybe it was not the chief but the mythical *Make Make* who made them walk. Or the priests who, with their chanting, each day coaxed the statues a little closer to the spots for which they were destined. However they arrived, the *moai* took up their appointed places on the *ahu* and fixed upon the villages their white and crimson eyes, carved of coral and scoria rock. And though the coral and the scoria have long since crumbled and their gaze has lost its power to transfix, still they stand, rigid, menacing, lips pursed in silent thought.

Ancient Sculptured Heads ⊹ Easter Island, South Pacific

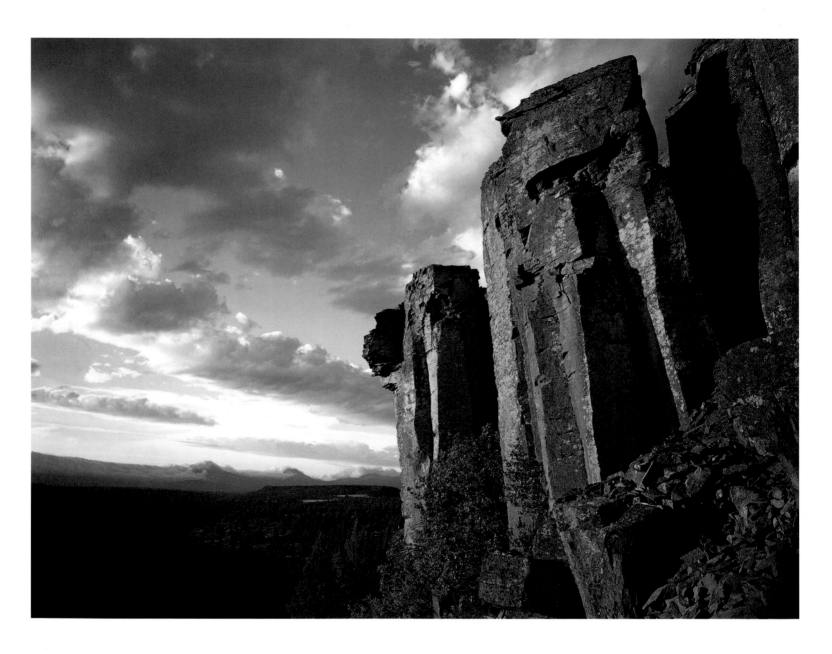

Orange Rocks ✛ Roads, Nevada

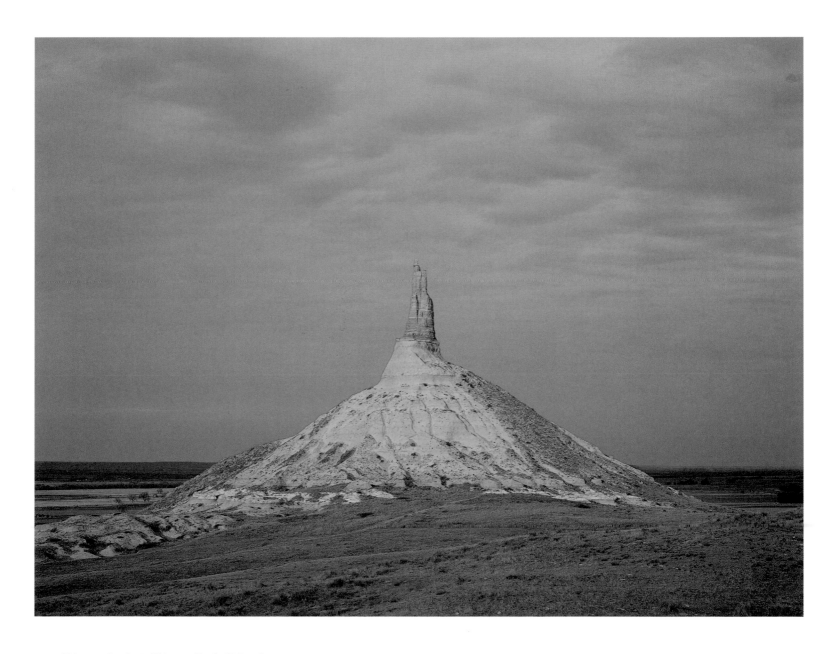

Chimney Rock ✧ Chimney Rock, Nebraska

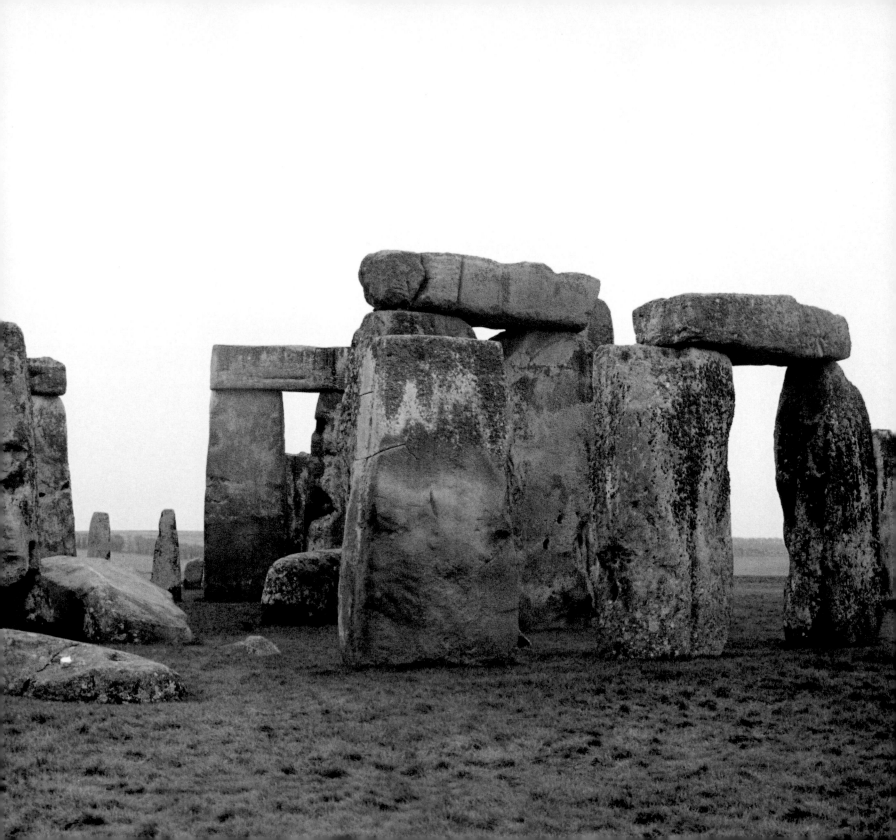

Three thousand years before Cheops ordered the building of the Great Pyramid at Giza, the Neolithic forebears of Europeans were arranging groupings of boulders, unwrought or roughly worked, into rings, more than nine hundred of which can still be found in various parts of the British Isles. The most famous of these is Stonehenge, a great circle of ponderous bluestone, micaceous, and sarsen blocks occupying nearly one hundred meters of the verdant Salisbury Plain before it ripples and swells into the bucolic hills of southern England. Built in three installments between 3300 B.C. and 1900 B.C., the "henge" that now remains comprises an outer ring of thirty lintel-capped stones around a horseshoe-shaped cluster of five trilithons, prodigious in size and weight—and in the speculation and legends that have grown up around them. Astronomical observatory, ceremonial building, seasonal clock: a trilogy of functions has variously been ascribed to the stone circles. Psychics and mystics claim to feel powerful, healing energies emanating from both below and above the Stonehenge monoliths and give credence to speculations that the structure was built on a site of mysterious terrestrial energy long perceptible to the indigenous peoples. Modern scientists have confirmed that the earth's magnetic field, influenced by the solar winds, by shifts in the magnetic core, and by the distribution of ferromagnetic components in the crust, waxes and wanes across the planetary face like a vast sea of energy. The cumulative effect of these fluctuations results in a complete reversal of the North and South magnetic poles about every five hundred thousand to one million years. Inexplicably, however, certain spots of the globe retain a constant electromagnetic force. Stonehenge stands on one of these. It is, we are told, both a calendar for calculating propitious dates for festivals of renewal and a sort of battery for collecting, storing, and eventually manifesting the earth energies at times when they are most highly influenced and "charged" by the sun, the moon, and the stars. Layamon, the Middle English poet of the thirteenth century, stood among those stones and, in his chronicle *Brut,* defined their magic. "The stones are great," he wrote. "And magic power they have/ Men that are sick/ Fare to that stone/ And they wash that stone/ And with that water bathe away their sickness."

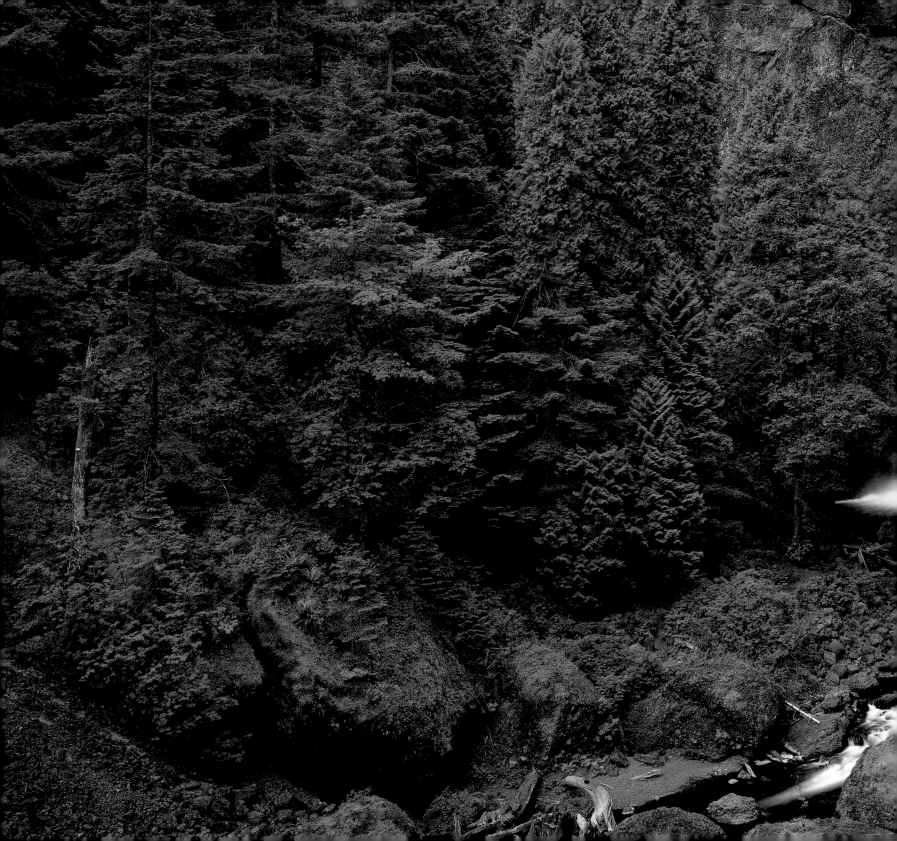

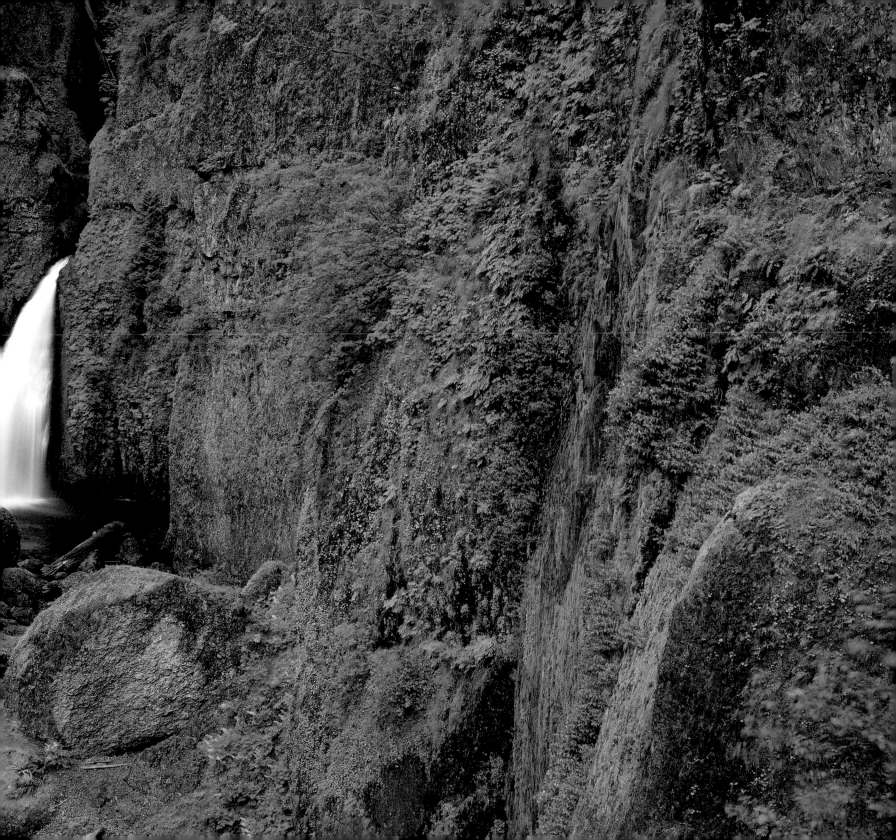

Then up the ladder of the earth I climbed
through the barbed jungle's thickets
until I reached you Macchu Picchu.

Tall city of stepped stone,
home at long last of whatever earth
had never hidden in her sleeping clothes.
In you two lineages that had run parallel
met where the cradle both of man and light
rocked in a wind of thorns.

Mother of stone and sperm of condors.

High reef of the human dawn.

Spade buried in primordial sand.

This was the habitation, this is the site . . .

— Pablo Neruda
The Heights of Macchu Picchu (excerpt)

Central Plaza ✛ Machu Picchu, Peru

previous pages: **Wahclella Falls** ✛ Columbia Gorge, Oregon

North Muddy Mountains ⁘ Nevada

Cities never die. They only hibernate. Even when their original inhabitants disappear and their buildings and streets and public squares crumble beneath the weight of time and nature's growth, cities endure as lures to the living. More directly than the written word or the painted image, the ruins of ancient cities travel with impunity to the heart and mind. Temples in Mesoamerica—Tikal in Guatemala, Picchu in Cuzco, Chichen Itza in the Yucatan—are signposts of lives once lived at fever pitch, of minds stretching to encompass all that could be known, of souls yearning for answers and transcendence. Haunted and haunting, these empty cities impinge on us more forcefully than nearly any other man-made object, because they alone, in their complexity and nuance, translate the will and vision of an epoch into the testament of space.

Chichen Itza ÷ Yucatan, Mexico

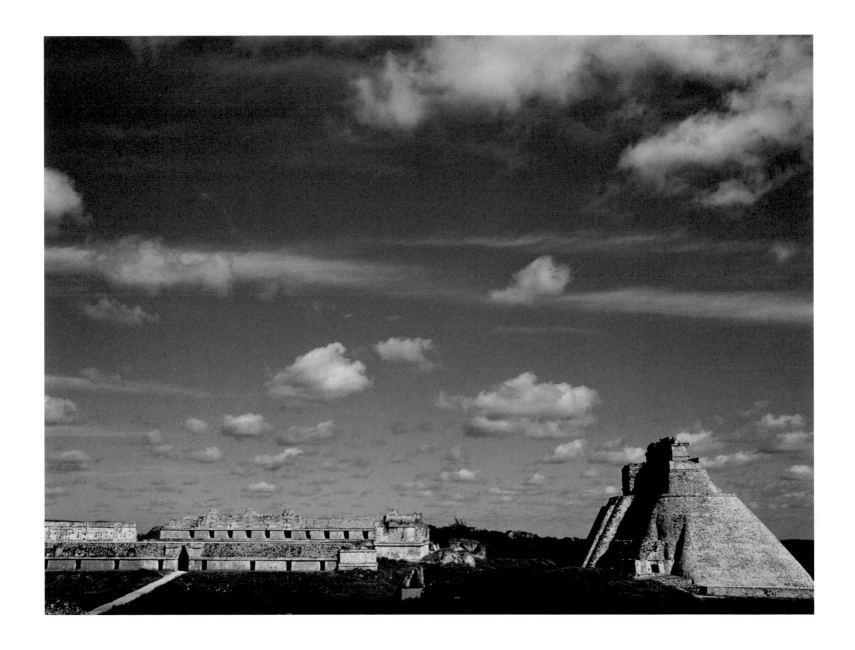

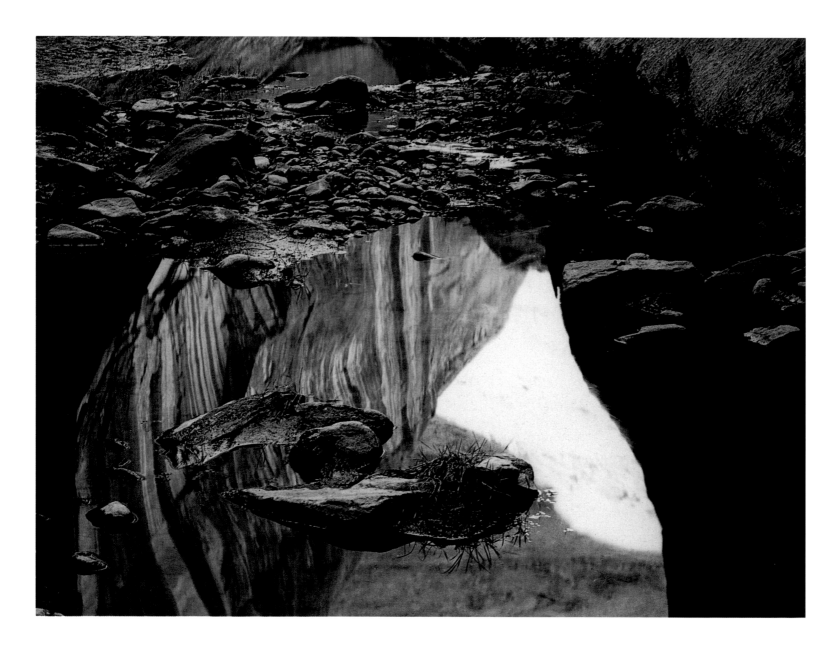

Hidden Passage ÷ Glen Canyon, Utah

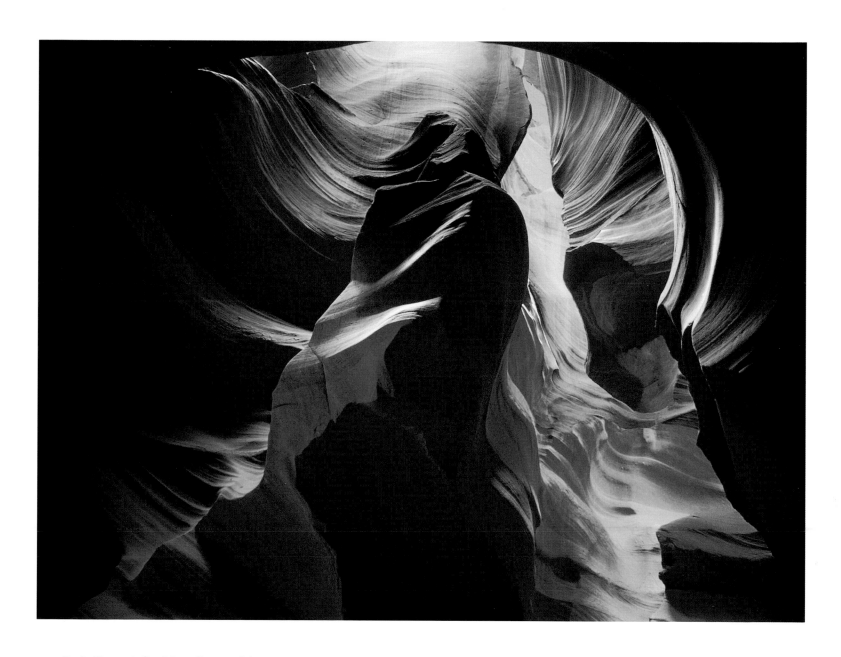

Rock, Water ✧ Sandstone Canyon, Arizona

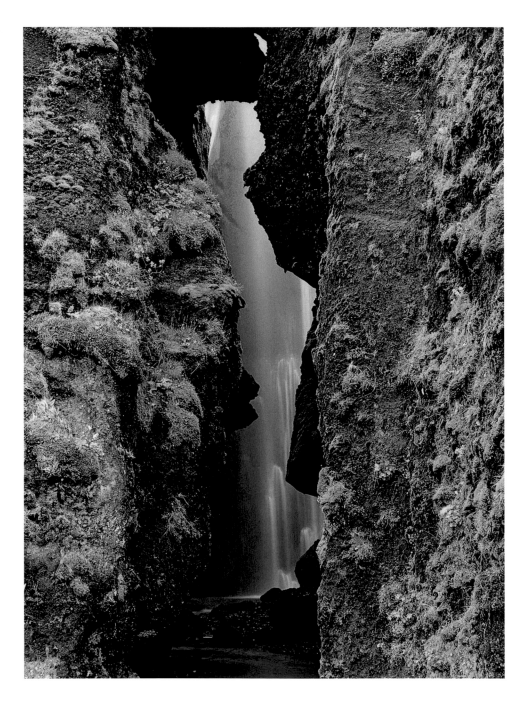

Waterfall, Crevice ÷ Road to Vik, Iceland

In the nineteenth century, the single most popular travel destination—in Europe, the Americas, Africa, and Australia—was the waterfall. When large enough, the waterfall was a catalyst for a whole range of powerful emotional and spiritual experiences that was explored and described in great detail by scientists, writers, and artists. These professional analysts of sensations provided something like instructional manuals that taught generations of secular pilgrims what to expect from and how to react to the baffling, chaotic performances of nature.

Judging by the responses left by tourists of both sexes, the waterfall offered a total stimulation, a synaesthetic blending of sound, sight, smell, touch, and taste that transported them to a new level of intensity. In the coded lexicon of Victorian propriety, the reactions of various female pilgrims to Niagara Falls border on the pornographic. "My dreams are very wild here," writes one. "I am not calm here." "I feel half crazy when I think of it," writes another. And Harriet Beecher Stowe revealed that she "felt as if I could have *gone over* with the waters; it would be so beautiful a death; there would be no fear in it." Small wonder then, that by the 1830s, waterfalls were already established as the favorite destination of newlyweds, a popularity that would only swell with the century.

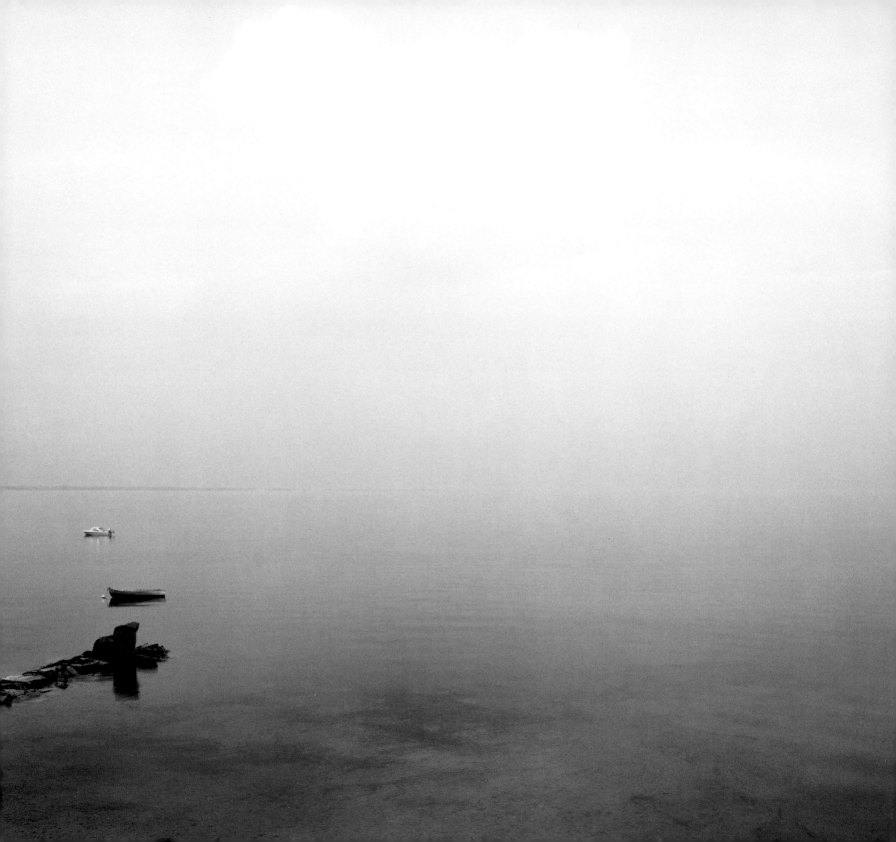

. . .

Dribbling droplets, soaking waters,
Dense and dark as clouds and fog;
Burbling streams trickling and trilling,
None failed to come pouring in.
Oh, this vast numinous sea,
Long has it received and transported!
Such breadth,
Such wonderment,
All befit its greatness!

. . .

— Xiao Tong
"Rhapsody on the Sea" (excerpt)

Sea, Sky, Cloud ⁙ Cape Cod, Massachusetts

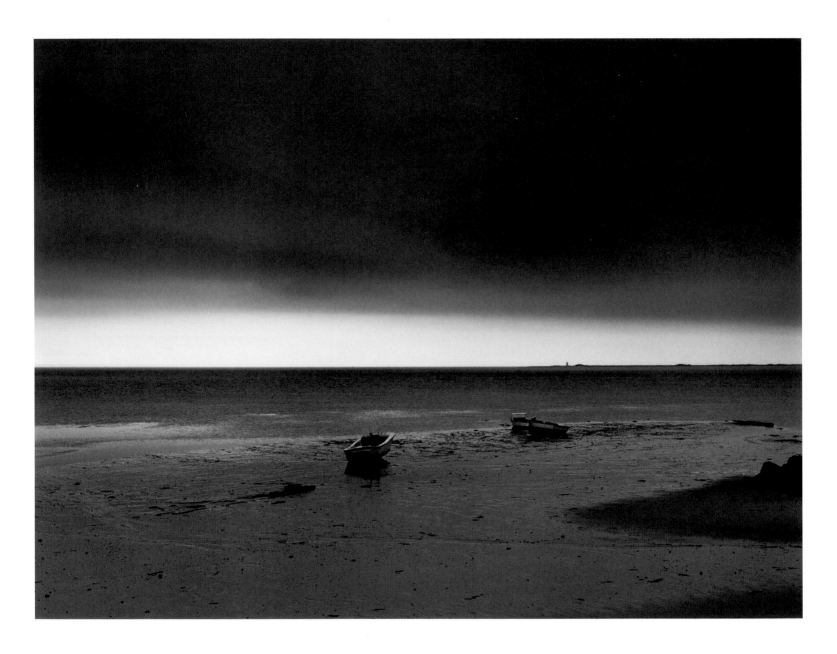

Sand, Sky, Cloud ÷ Cape Cod, Massachusetts

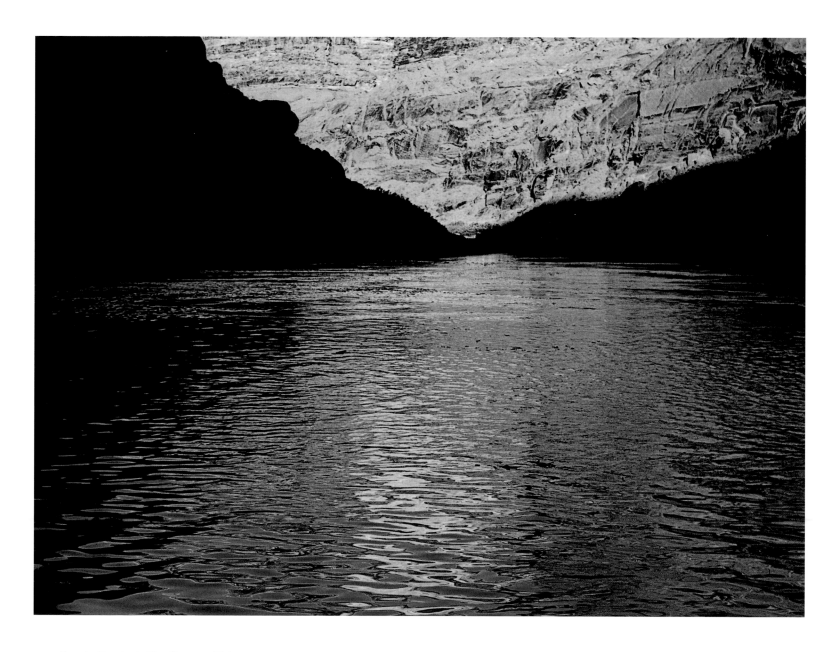

Navajo Creek ⊹ Glen Canyon, Utah

With its vertiginous abysses, brilliantly hued formations of eroded sandstone, and sheer massive walls, the Grand Canyon inspires myth and incubates mystical experiences. Descending along its crumbling ledges and narrow paths into the very core of the earth, the Native American tribes who settled here over the millennia have revered this extensive system of canyons as "Mother." For the Anasazi and the Pueblo peoples descended from them, the canyon depths represent the *sipapu,* or *shipapu,* the emergence point from which their ancestors passed into the world. According to myth, the First People, led by the flute-playing Locust, entered this world from the Third, or Lower, World, through the *sipapu.* A long, long time ago, before Cayote covered the hole with a stone, the dead were able to pass into the spirit world through this portal and reemerge, some days later, with their revived bodies intact. But since Cayote's prank, only spirits such as the *kachinas* can pass freely through *sipapus.* To this day, Native Americans seek out sources of powerful primordial energy among the Grand Canyon's clefts, scars, and fissures, and tap into the powerful primordial energy of these sites at turning points in their lives.

Deer Creek ÷ Grand Canyon, Arizona

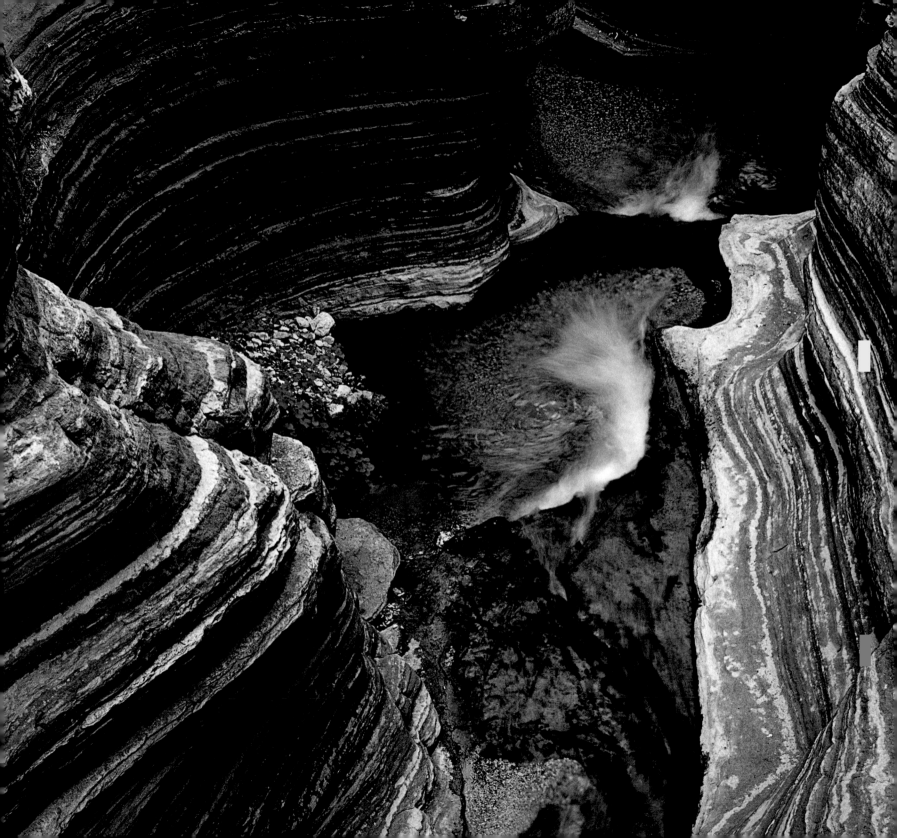

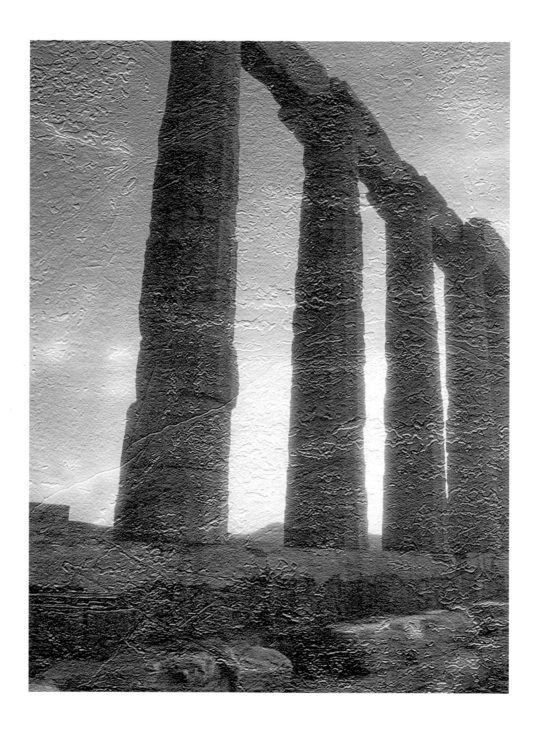

Their healing properties made mineral springs a standard item in the pharmacopeia of healers from antiquity, such as Hippocrates, Celsus, Caelius Aurelianus, and Galen. Throughout the Peloponnese, wherever natural springs gushed and burbled from the flinty earth, the ancient Greeks built sanctuaries that doubled as medical centers dedicated to Asklepios, the god of healing. Patients seeking Asklepios's assistance first drank and then bathed in the sacred waters, before retiring to his temple, or Asklepion, to sleep. Upon awakening, they recounted their dreams to a priest-healer who read them for whatever clues they might provide as to the nature of the maladies and the advisable course of treatment. In due course of time, the pagan shrines were assimilated into Christian places of worship and rededicated to various *Aghioi Anargyroi,* or doctor saints, whose supernatural ministrations were no less effective to believers.

Temple of Poseidon ✧ Soúnion, Greece

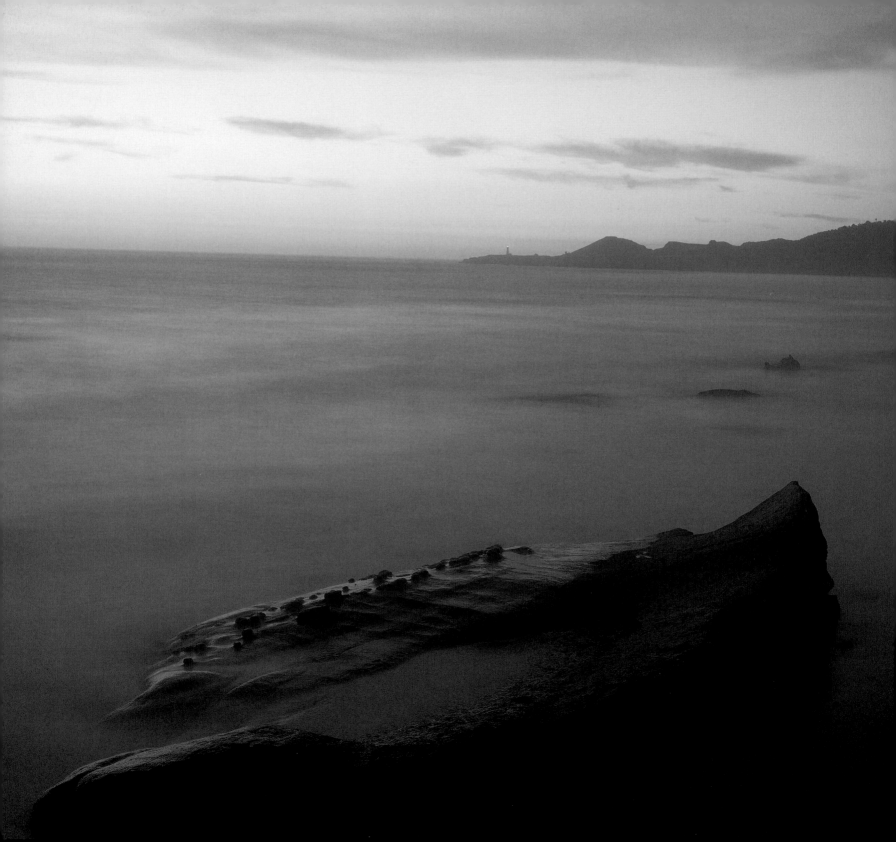

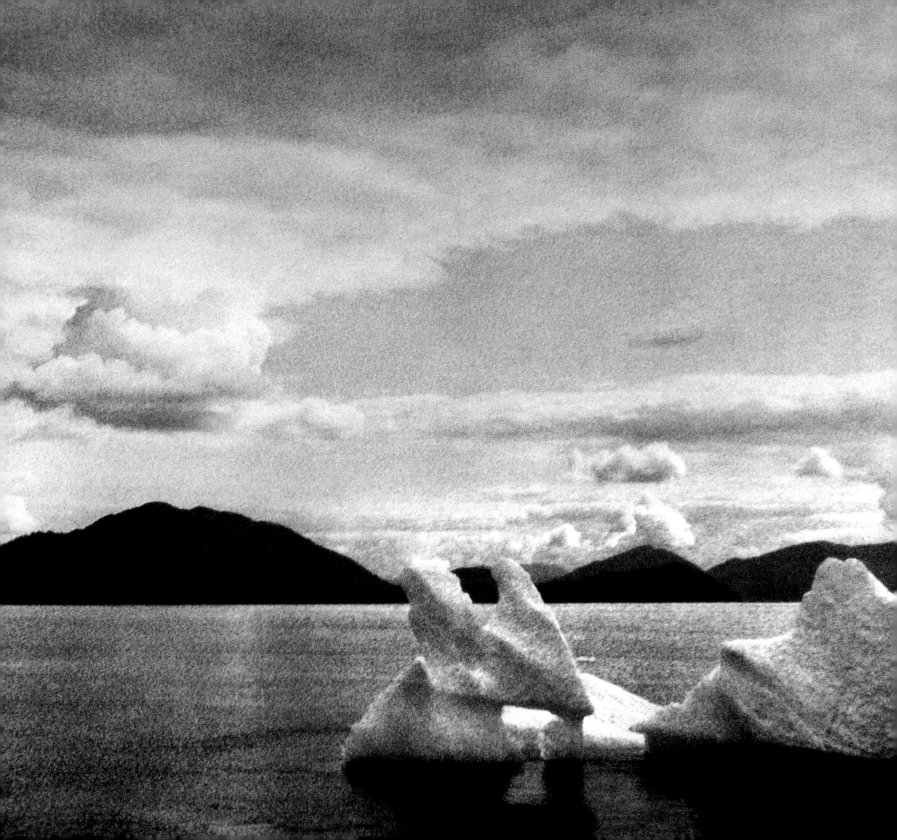

A magnificent thing it is, in infinite solitude by the sea,

beneath a sullen sky, to gaze off into a boundless watery waste. . . .

Nothing could be sadder or more discomfiting than just this position in the world:

the single spark of life in the vast realms of death,

the lonely center in the lonely circle. . . .

— Heinrich von Kleist
"Feelings before Friedrich's Seascape" (excerpt)

Desert Dunes ✦ Sahara, Africa

previous pages, left: **Nye Beach** ✦ Newport, Oregon

previous pages, right: **Sea and Ice** ✦ Alaska

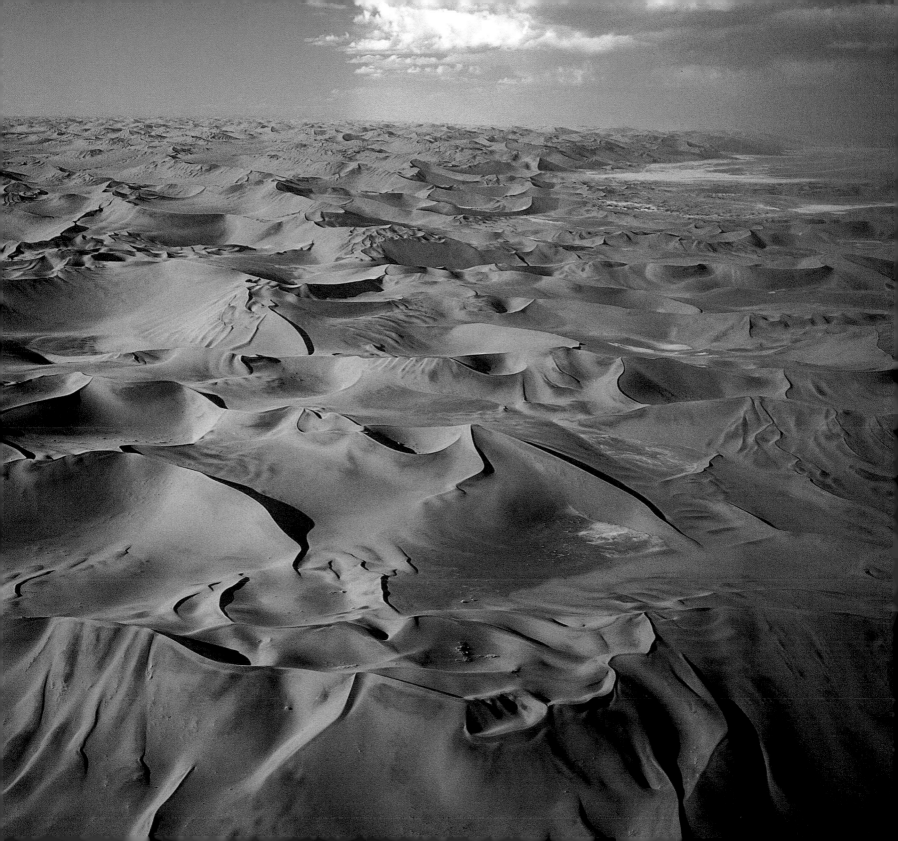

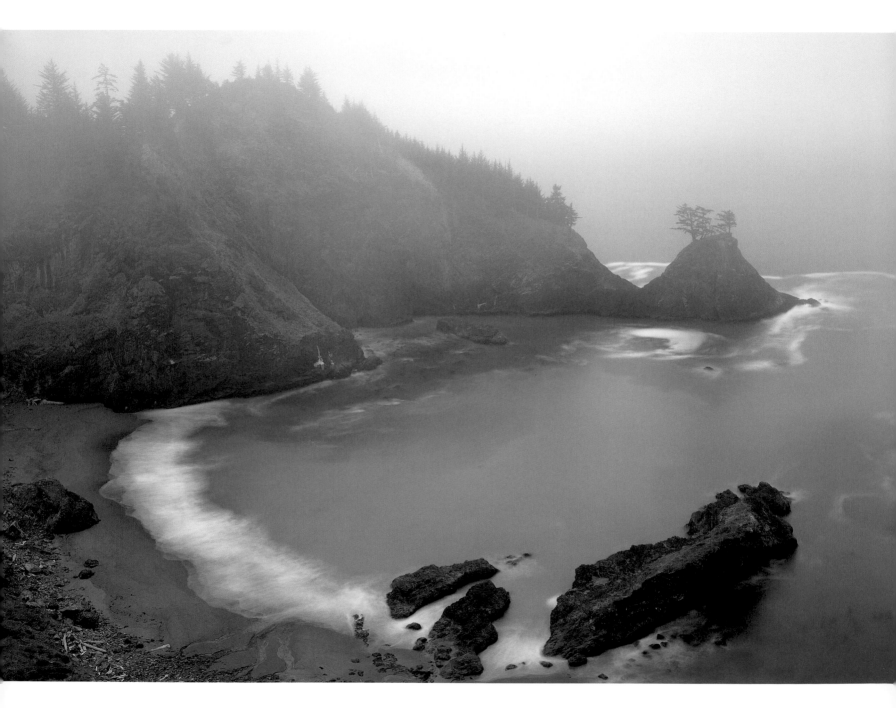

There is a pleasure in the pathless woods,
There is a rapture on the lonely shore,
There is society, where none intrudes,
By the deep Sea, and music in its roar:
I love not man the less, but Nature more,
From these our interviews, in which I steal
From all I may be, or have been before,
To mingle with the Universe, and feel
What I can ne'er express, yet cannot all conceal.

— **Lord Byron**
Childe Harold's Pilgrimage (excerpt)

Fog ÷ Near Brookings, Oregon

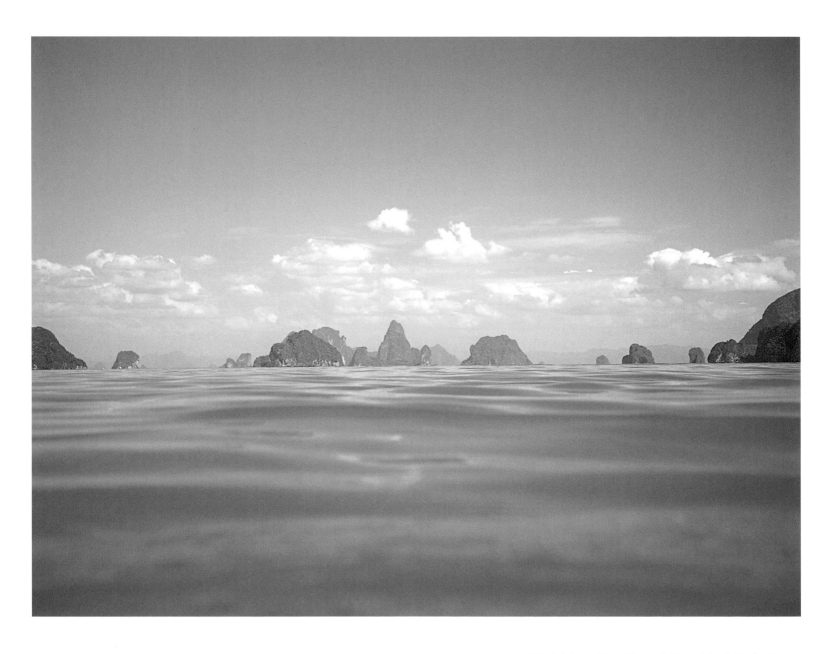

Black Island, Blue Water ÷ Hong Island, Thailand

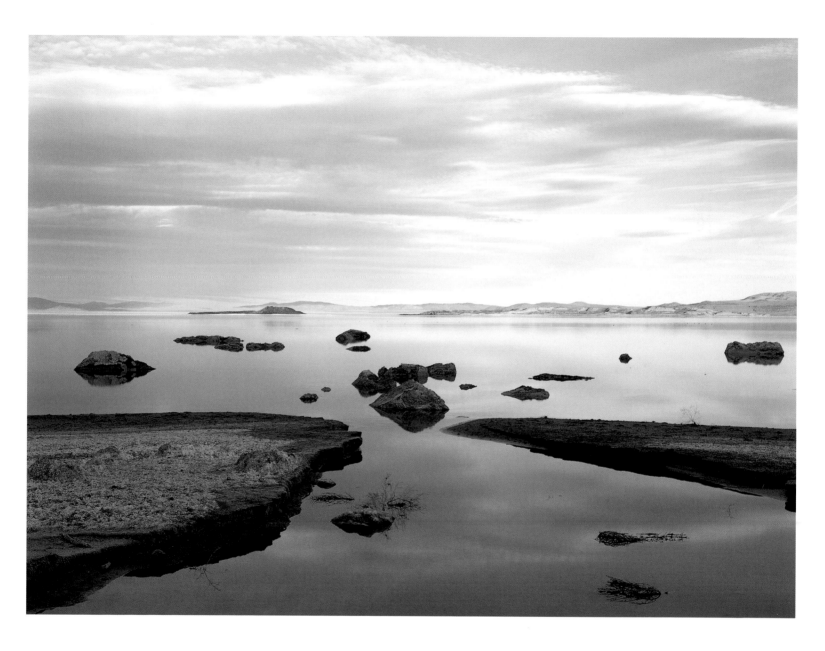

Approaching Twilight ✦ Mono Lake, California

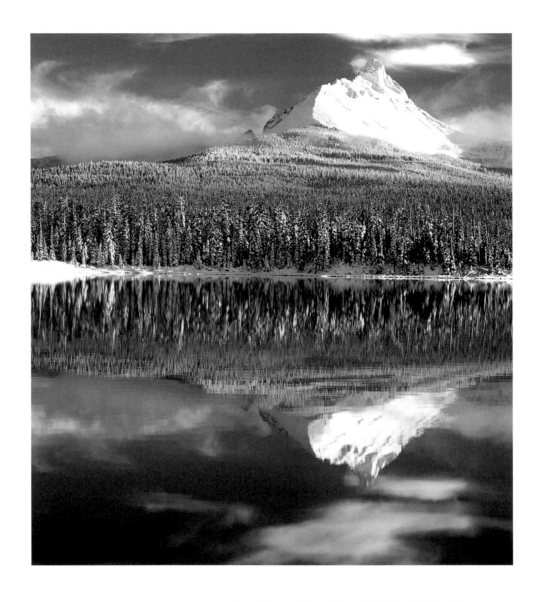

Snow-Capped Mountains ÷ Mt. Washington, Oregon

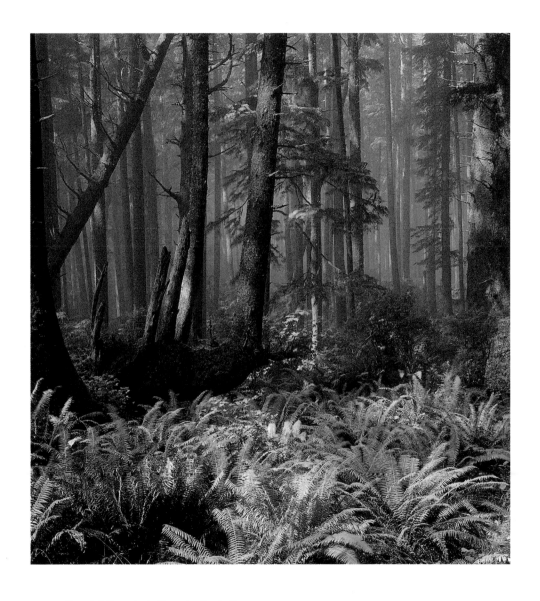

Coastal Forest ⁜ Cape Lookout, Oregon

Winds play a subtle, often decisive role in the sedative effect of a particular landscape. Although not as readily evident as such three-dimensional features as rocks, gullies, forests, and waterfalls, winds are an integral component of the topographical character of a site. The extensive lexicon of wind names, which in English alone lists over one hundred separate items, only hints at the rich diversity of air currents that animate the surface of the earth. Some—such as the Greek "Zephyros"—are seasonal; others—such as the Harmattan or "Cape Doctor" of the South Africa coast—are local. Both of these are beneficent and believed to impart healthful properties to the locales through which they pass. By contrast, winds such as the Mediterranean's Mistral, the Adriatic's Bora, and the Rocky Mountain Chinook are reputed to produce disagreeable physical symptoms that range from irritation and headaches to lethargy and madness. Pausanias, the ancient Greek traveler of the late first century A.D., described one such noxious wind he encountered on the islands off the coast of Athens. "The wind called Lips," he writes, "striking the budding vines from the Saronic Gulf, blights their buds. So while the wind is still rushing on, two men cut in two a cock whose feathers are all white, and run round the vines in opposite directions, each carrying half of the cock. When they meet at their starting place, they bury the pieces there. Such are the means they have devised against the Lips."

Desert Dunes ÷ Sahara, Africa

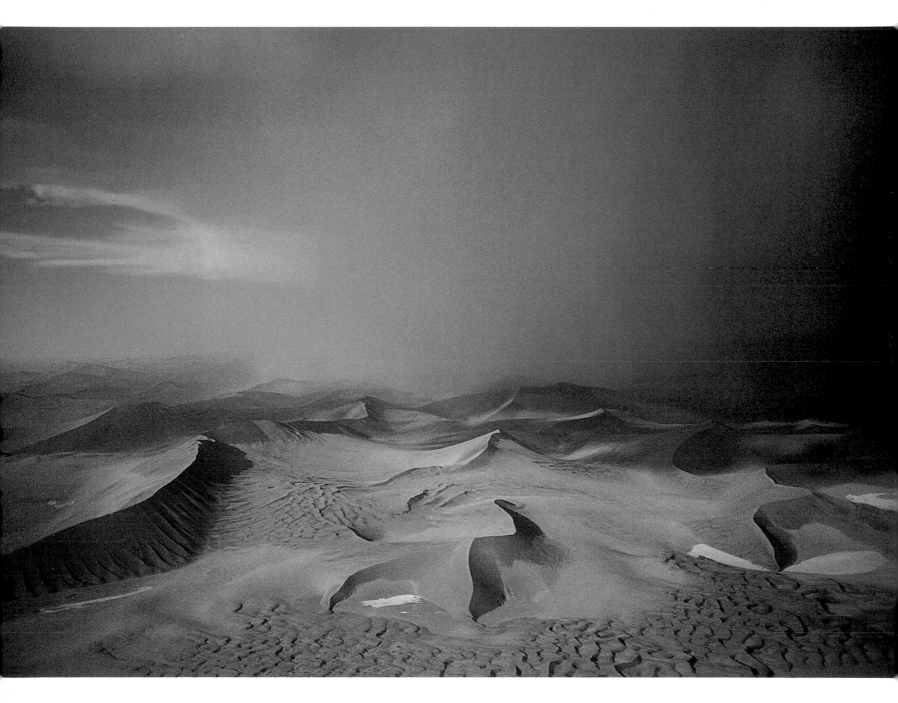

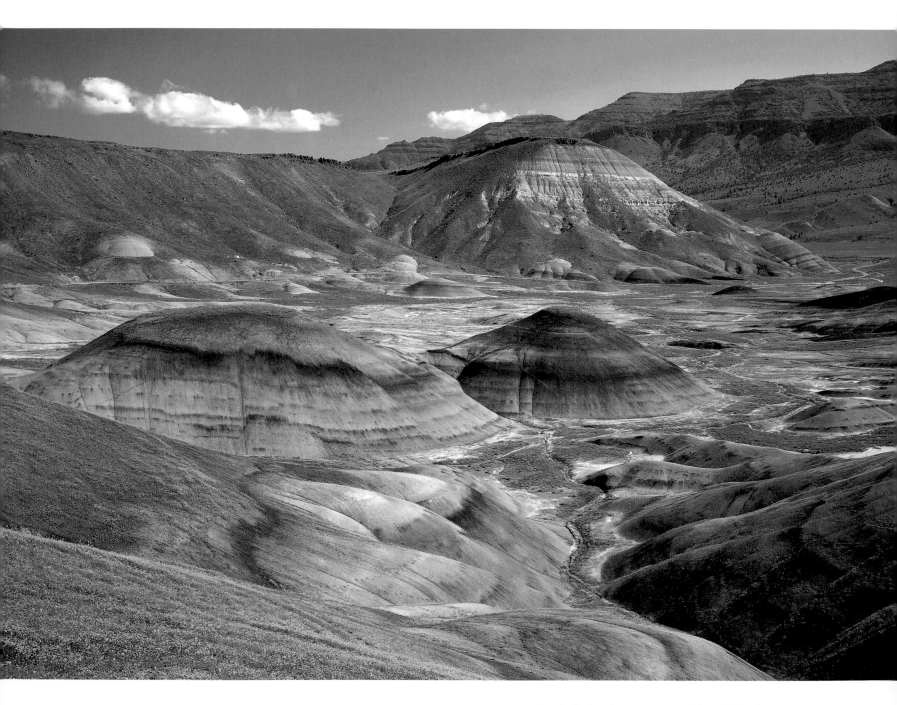

Fossil Beds National Monument ÷ Painted Hills, Oregon

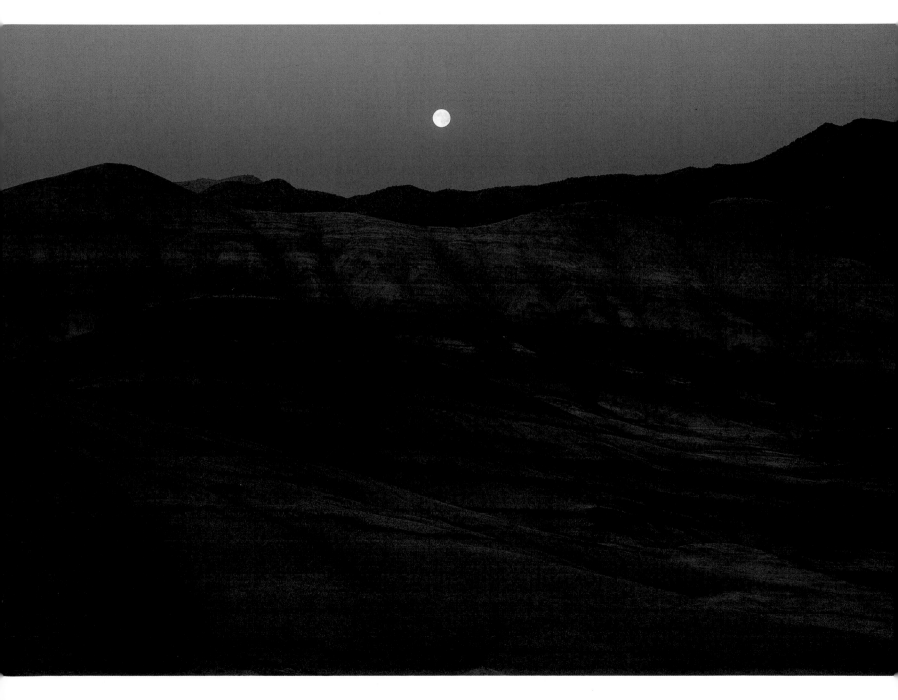

Moonrise ‡ Painted Hills, Oregon

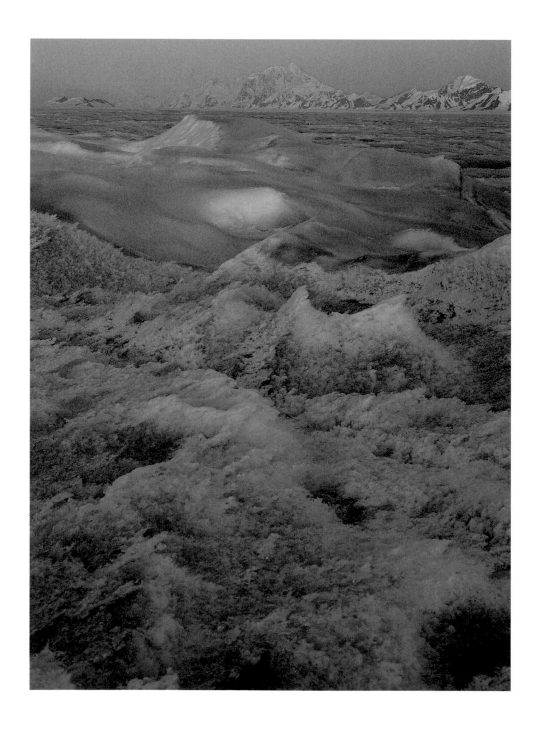

The soul ascends, the vision of the spirit tends to expand,
and in the midst of majestic silence one seems to hear
the voice of nature and to become certain of its most secret operations.

— **Horace Benedict De Saussure**
Voyages in the Alps (excerpt)

Snow-Capped Mountains ✧ Wrangell St. Elias National Park, Alaska

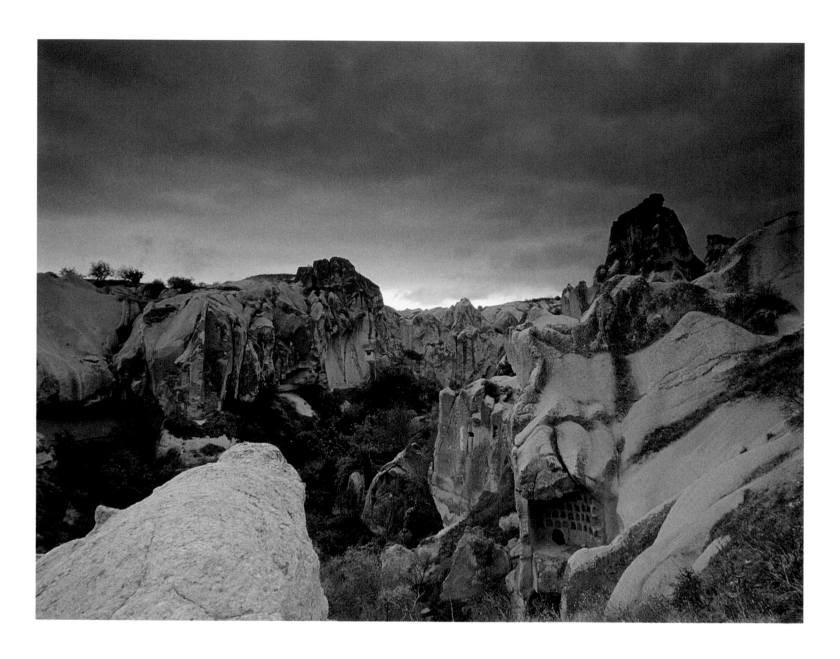

Rocks ÷ Cappadocia, Turkey

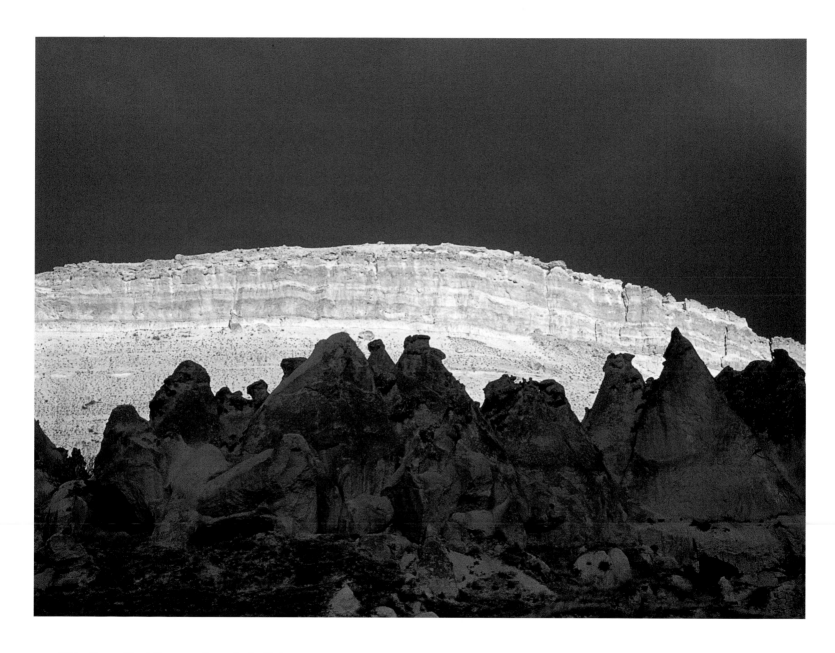

White Butte, Black Trees ✛ Cappadocia, Turkey

The British, Continental, or American artist who, late in the eighteenth century, headed into the wilderness of the Old and New Worlds seeking sublime subjects for ambitious, light-drenched paintings was the forerunner of the eco-tourist of the twenty-first century. Romantics, such as the French Eugène Delacroix, the British J.M.W. Turner, or the German Caspar David Friedrich, embarked on the aesthetic equivalent of the religious pilgrimage, because in the landscape untouched by Western civilization they thought they found traces of a primordial, lost innocence, the natural equivalent of the Garden of Eden. Their pilgrim's shrine became the overpowering bleakness and beauty of forbidding mountains, angry seas, and menacing desert sands. Looking outward, they explored the mysterious terrain of their own souls, recording their emotional responses to strange and unusual lands and, in the process, forging a sense of communion with nature.

Sunset, Mt. Hood ✣ Mt. Hood National Forest, Oregon

previous pages: **Unnamed Playa by Moonlight** ✣ Utah

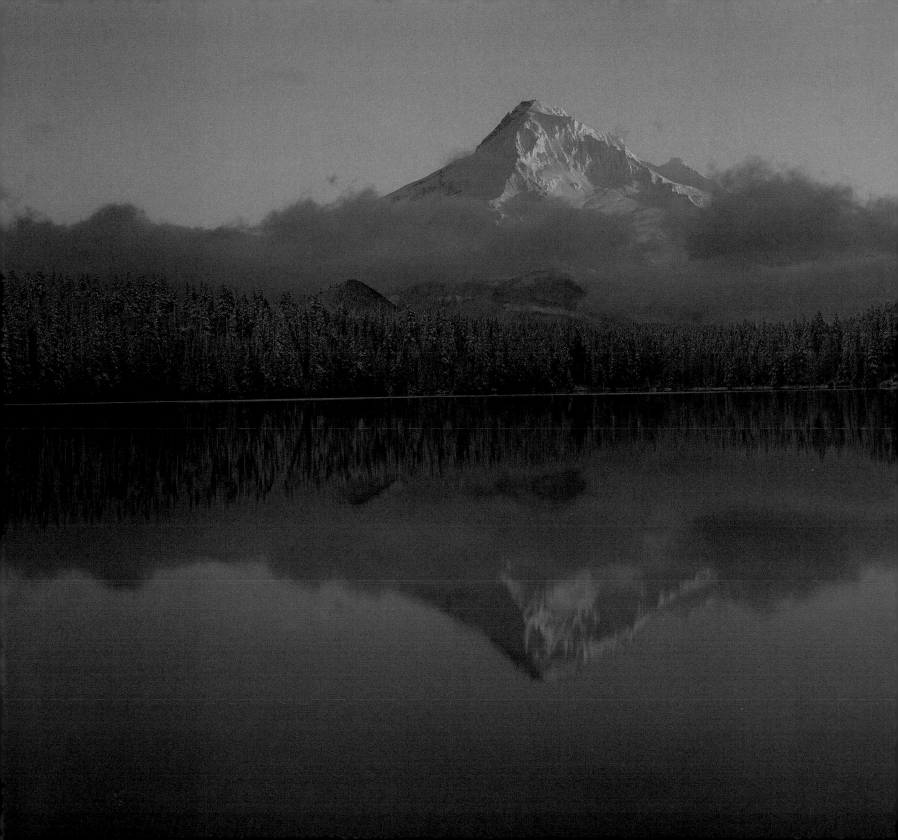

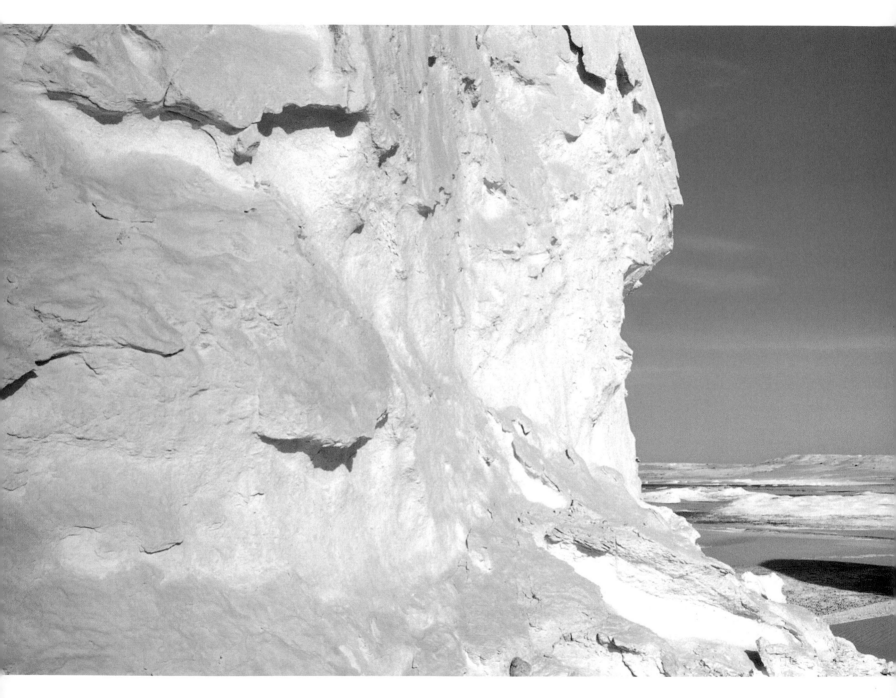

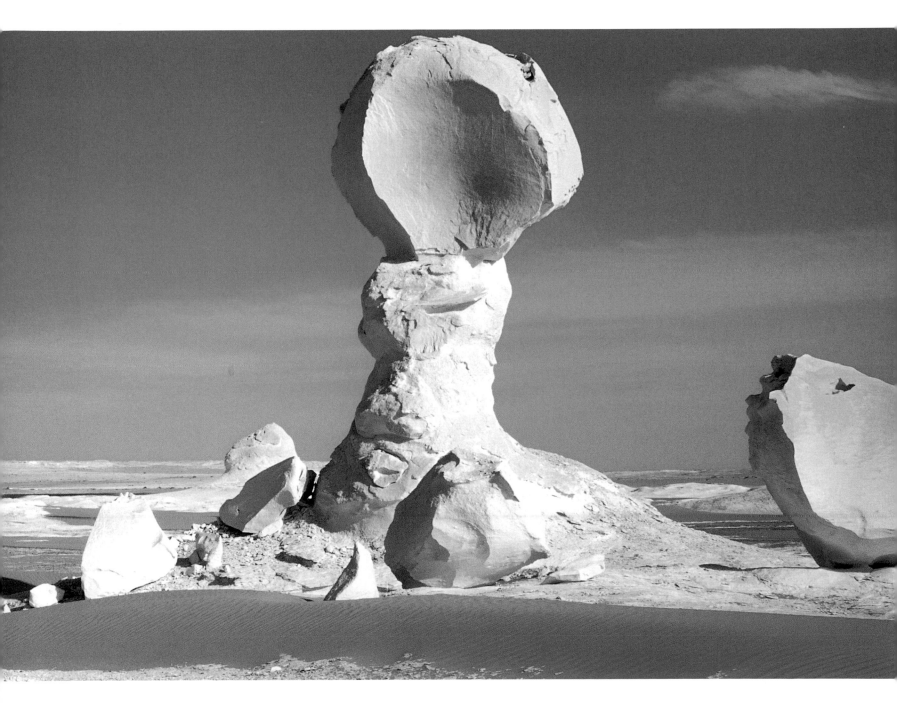

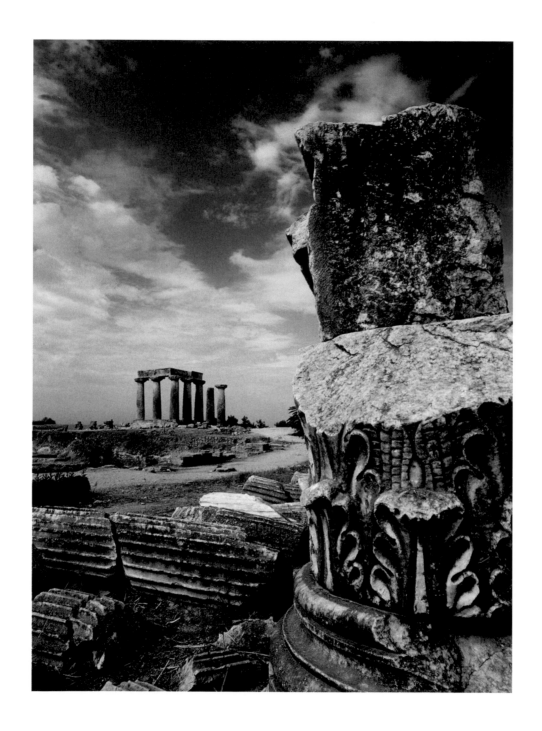

The ruins of ancient civilizations are popular pilgrimage destinations, but the temples of ancient Greece are particularly compelling, rooted as they are in a heavenly mythology that is part of the foundation of Western culture. Once bustling centers of worship, temple sites throughout the Peloponnese now exude a vacant stillness. The worn, mottled piles of dismembered stones and sun-bleached columns of once magnificent structures, such as the mid-fifth-century B.C. Temple of Apollo in Corinth, slice into skies as black as obsidian. Buildings that once thrummed with orators and poets, politicians and merchants, priests and supplicants, are now an abstract scattering of monoliths, robed in the silence of advancing moss, unexhumed for centuries, left to decompose in a forgotten cove of Grecian space that nevertheless still rings with the tribulations of gods and goddesses.

Greek Temple ✦ Korintiaosa, Greece

previous pages: **White Desert** ✦ Egypt

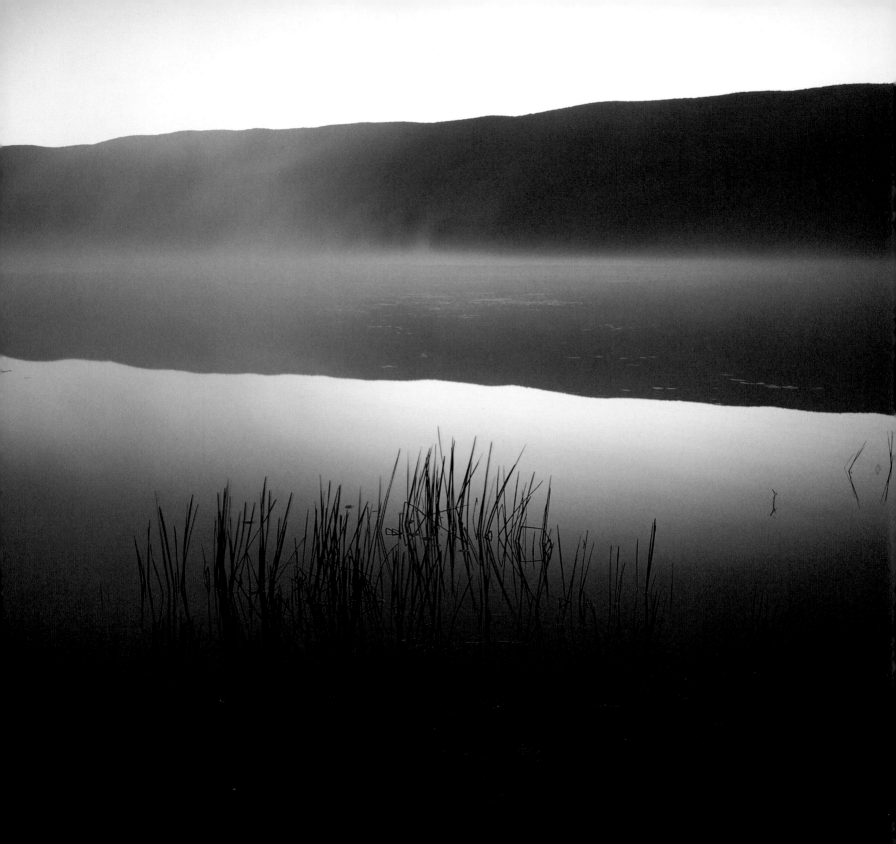

. . . 'tis the sense
Of majesty, and beauty, and repose,
A blended holiness of earth and sky,
Something that makes this individual Spot,
This small Abiding-place of many Men,
A termination, and a last retreat,
A Centre, come from wheresoe'er you will,
A Whole without dependence or defect,
Made for itself, and happy in itself,
Perfect Contentment, Unity entire.

— **William Wordsworth**
The Recluse, Part First, Book First
"Home at Grasmere" (excerpt)

Mauserts Pond ✛ Clarksburg State Park, Massachusetts

Between the two huge and barren expanses of desert to the East and West, ancient Nubia writhes like a green sand-worm along the course of the river. Here and there it disappears altogether, and the Nile runs between black and sun-cracked hills with the orange-drifting sand lying like a glacier in their valleys. Everywhere one sees traces of vanished peoples—the Meroites, Blemmyes, Bedja—and the submerged civilizations of the Persians, Ptolemies, and Romans. Grotesque ruins dot the hills or stand up against the skyline. Here and there, set back from the riverbanks, a deserted city of walls and battlements rises up above the piles of rock, the sun shining through the empty squares of windows. Beyond the grim, mute cities, far back in the smudge of hills, lie clusters of tombs, abandoned to the desert and the wind.

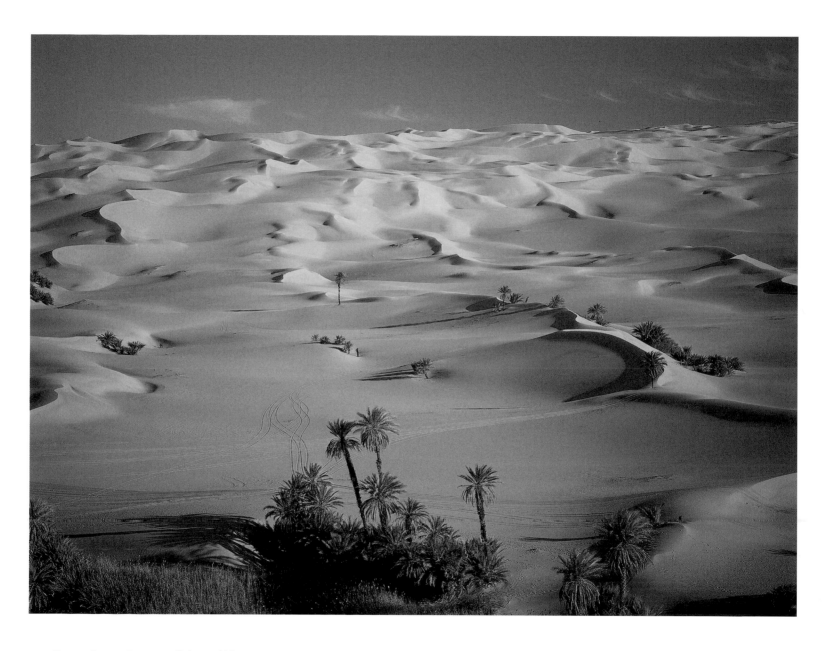

Desert Sands, Palms ✣ Sahara, Africa

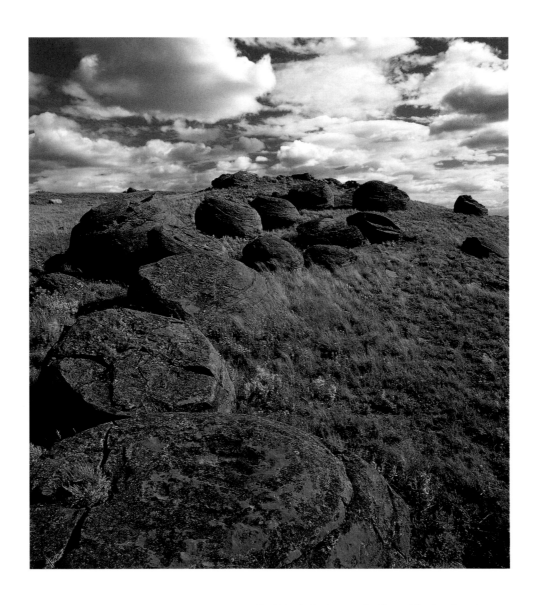

Red Rock Coulee ⁂ Southern Alberta, Canada

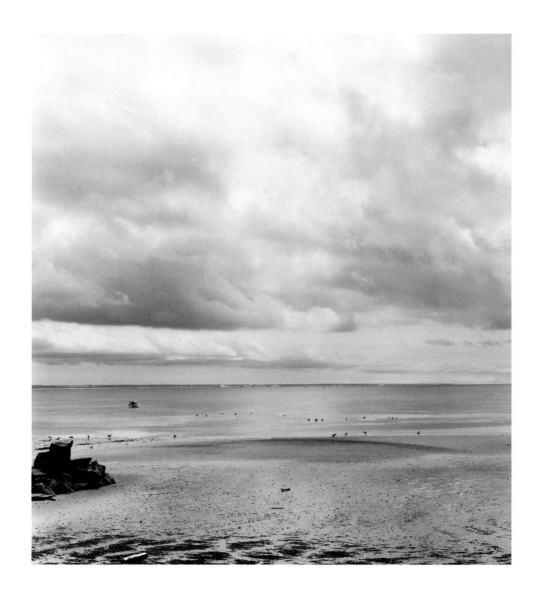

Beach, Tide Pool, Sea ✣ Cape Cod, Massachusetts

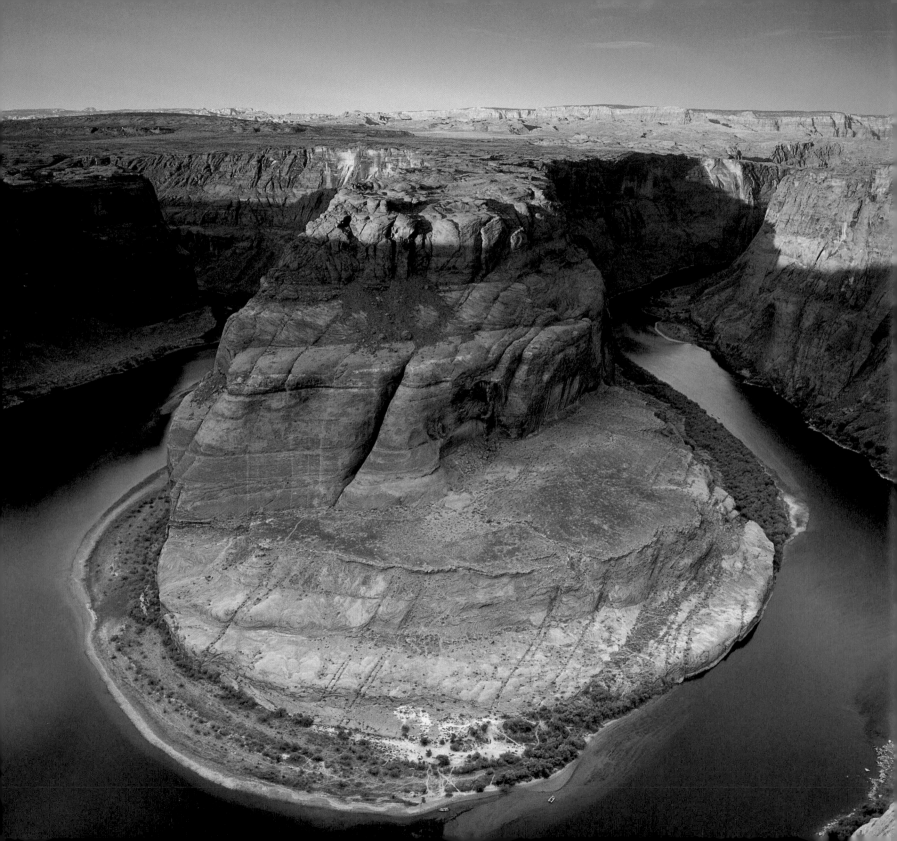

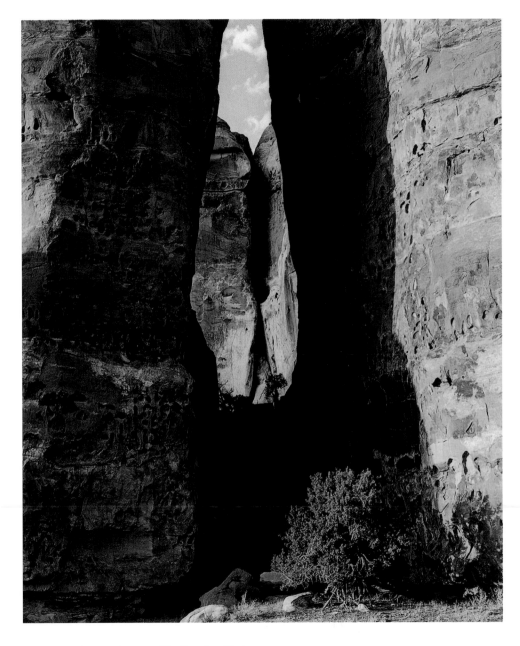

Chestler Park ÷ The Needles, Utah

Colorado River ÷ Near Page, Arizona

. . . stand on the peak of the mountain, contemplate the long ranges of hills, observe the courses of rivers and all the glories offered to your view, and what feeling seizes you? It is a calm prayer, you lose yourself in unbounded space, your whole being undergoes a clarification and purification, your ego disappears, you are nothing, God is everything.

— **Carl Gustav Carus**
Nine Letters on Landscape Painting (excerpt)

Rainbow, Butte, Sky ✦ Southwest National Park, Tasmania

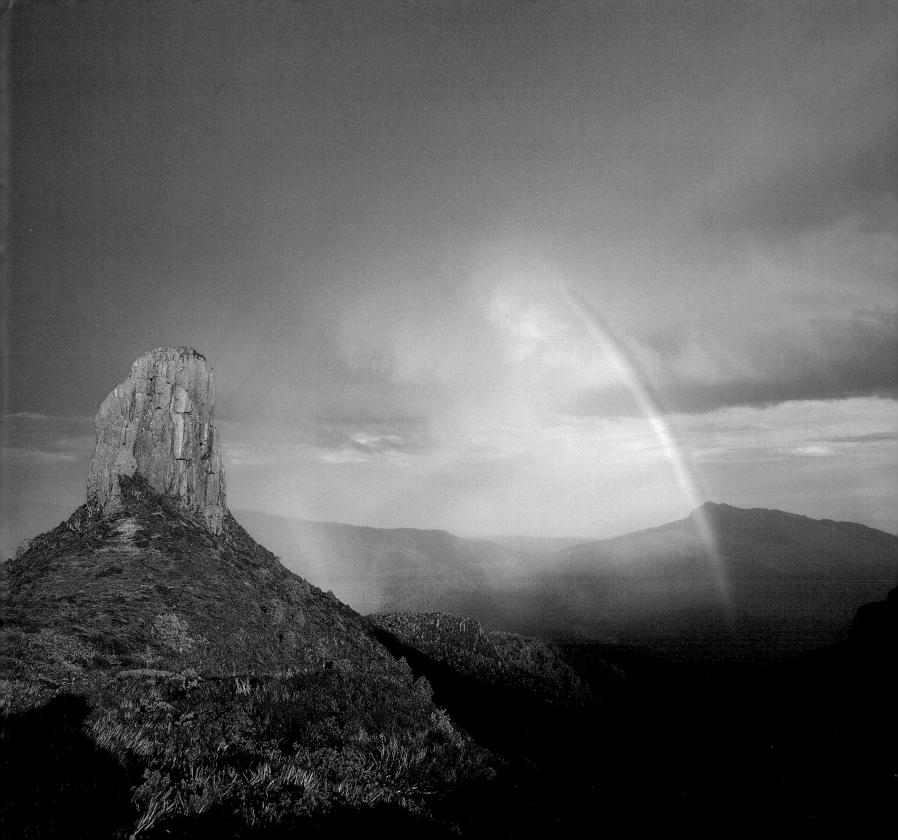

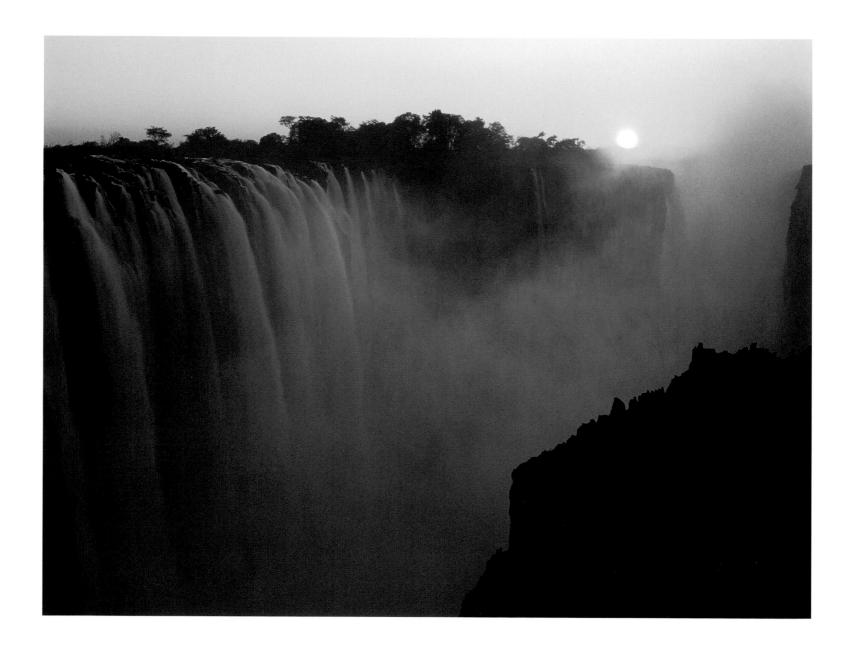

For nineteenth-century thrill-seekers, nothing rivaled walls of water rushing and tumbling in a chaos of tumult, spray, and mist. Long before they could see the source, visitors could feel a deep, dull vibration, a foretaste of the concussive battering of water against rock. As they drew near, their ears were assaulted by a rumbling, bass roar: the bigger the falls, the louder the tumult—louder than any natural sound they were likely to encounter in the age before amplified sound. When first approaching Niagara Falls, for example, Nathaniel Hawthorne listened for "the roar of the cataract, and trembled with a sensation like dread, as the moment drew nigh, when its voice of ages must roll." Travelers embarked on arduous journeys to encounter hydro-energy in its raw state and took pains to follow a prescribed ritual of approaching the falls so as to maximize this uniquely thrilling, regenerative event. The long, physically taxing passage into wilderness culminated in a harrowing ascent to the head of the falls. There, poised precariously on a slippery outcrop, the traveler stood deafened, blinded, and drenched by the explosive cascades. The proximity to danger, the sensation of standing at the very source of primordial power, the virginal lushness of nature—all this produced an incomparable sensation of awe, terror, and joy, that, in the aesthetic vocabulary of the time, went under the label of "the sublime." Seekers after this intense personal experience fanned out across the continents, comparing various cataracts for their degrees of rapture, ferreting out ever more inaccessible and unexplored cascades. As tourists swarmed to such "blockbusters" as Niagara Falls and Victoria Falls, connoisseurs made their way to less spectacular, but equally inspiring, waterfalls tucked away in remote corners of less-visited countries.

Victoria Falls ✛ Zimbabwe

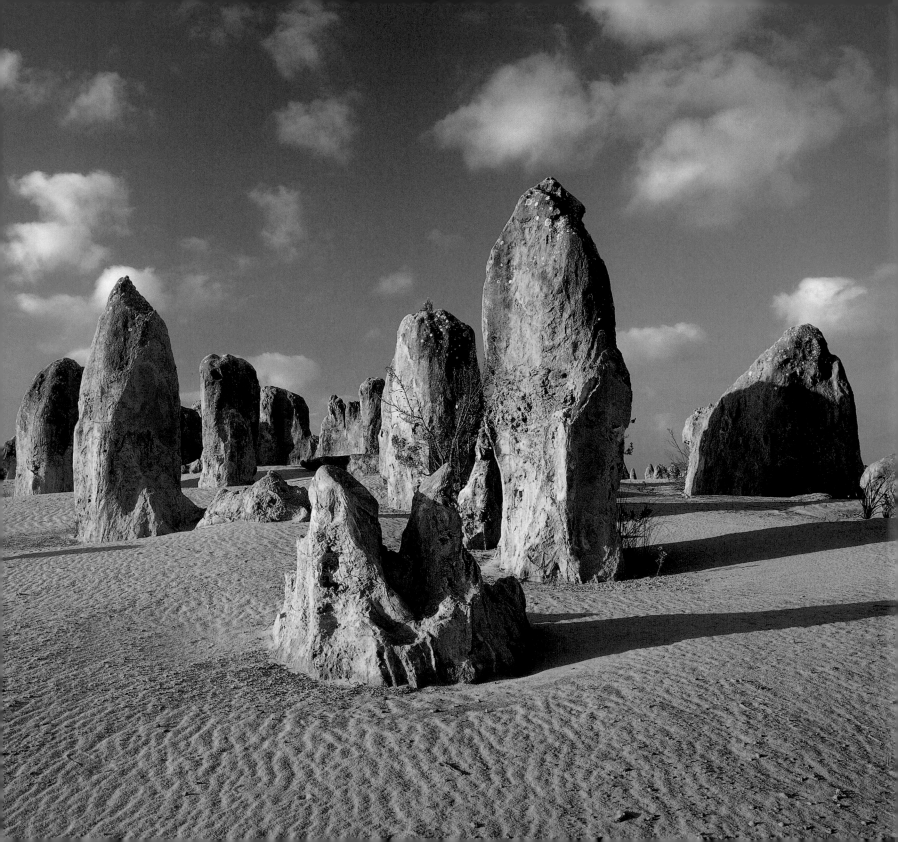

The Perfect Pilgrimage

The ideal pilgrimage, to our way of thinking, is as good for the soul as it is for the senses. The launch pad from which one inaugurates voyages to sites of primordial splendor and spiritual transcendence is crucial to the entire experience. In the following list, we offer our suggestions for some of the world's most intelligent, harmonious, and serene gateways—from both land and sea—to the pilgrimage experience.

From land, we include the internationally positioned Amanresorts and Mahakua resorts, ultimate portals to the sacred sites of Indonesia and the natural shrines of volcanic, oceanic, and desert environments. As elegant and perfectly situated are the Orient Express hotels, resorts, safari camps, and treks. This global network of properties provide unsurpassed access points to Africa, the Caribbean, South America, and Europe through historically and culturally significant accommodations. Whether trekking up the ancient steps of Macchu Picchu or elephant watching on safari, there is no better place to combine the refinements of cultural immersion with the grandeur of nature in her finest form. In India, the Oberoi hotels and resorts crystallize the unique features of pilgrimage sites that prime the visitor's receptiveness to the distinctive sense of place. Each of the world-class accommodations listed offers a range of physical, cultural, educational, and spiritual activities to facilitate a meaningful experience for the traveler.

The high seas and waterways of the world have become a magnetic piece of planetary real estate for those who want to pilgrimage in search of adventure, exotic encounters, and mystery. Today, there are more options than ever, from luxury cruise ships and chartered yachts to bareboats (boats without captains or crews) and canoes, for navigating oceans and rivers around the world. The Seabourn fleet are the best floating yachts in the world, and the fact they can transport you to magisterial planetary outposts from Alaska and Myanmar to Vietnam and Australia confirms that these ocean cruisers and their itineraries are designed to penetrate every magnificent nook and cranny the globe has to offer. The modernistic and elegant *Pride, Spirit,* and *Legend* each accommodate about 200 passengers and are much smaller than ocean liners such as the *QE2* (which accommodates about 2,200 passengers). Imagine sailing the globe with a ballet-and-dinner gala in a St. Petersburg's palace on one itinerary and a private visit to Peggy Guggenheim's Museum in Venice on another. What follows is our list of handpicked cruise ships, yacht bareboat brokers, and rafting outfits that provide the best-in-class service for everyone who wants a world-class experience from their sail-away adventure.

The Pinnacle ⊹ Nambung National Park, Australia

By Way of Land

Africa

Amanjena
Marrakech, Morocco
TEL: (212 44) 403 353
FAX: (212 44) 403 477
www.amanresorts.com

Gametrackers—Botswana
Savute Elephant Camp, Eagle Camp,
Khwai River Lodge
Okavango Delta, Botswana
TEL: (27 11) 481 6052
FAX: (27 11) 481 6065
www.africangamelodges.com

Mombasa Serena Beach Hotel
Shanzu Beach, Mombasa, Kenya
TEL: (254 1) 148 5721
FAX: (254 1) 148 5453
www.serenahotels.com

Mount Nelson Hotel
Cape Town, South Africa
TEL: (27 21) 483 1000
FAX: (27 21) 424 7472
www.mountnelson.co.za

Victoria Falls Hotel
Victoria Falls, Zimbabwe
TEL: (263 13) 4751 60
www.meikles.com

Asia

Amandari
Kedewatan, Ubud, Bali, Indonesia
TEL: (62 361) 975 333
FAX: (62 361) 975 335
www.amanresorts.com

Amanjiwo
Borobudur, Central Java, Indonesia
TEL: (62 293) 788 333
FAX: (62 293) 788 355
www.amanresorts.com

Amankila
Manggis, Bali, Indonesia
TEL: (62 363) 41333
FAX: (62 363) 41555
www.amanresorts.com

Amanpulo
Pamalican Island, The Philippines
TEL: (63 2) 759 4040
FAX: (63 2) 759 4044
www.amanresorts.com

Amanpuri
Phuket, Thailand
TEL: (66 76) 324 333
FAX: (66 76) 324 100, 324 200
www.amanresorts.com

Amanwana
Moyo Island, West Sumbawa
Regency, Indonesia
TEL: (62 371) 22233
FAX: (62 371) 22288
www.amanresorts.com

The Oberoi
Denpasar, Bali
TEL: (62 361) 73 0361
FAX: (62 361) 73 0791
www.oberoihotels.com

The Oberoi
Medana Beach
Lombok, Indonesia
TEL: (62 370) 638 444
FAX: (62 370) 632 496
www.oberoihotels.com

Raffles Grand Hotel D'Angkor
Siem Reap, Cambodia
TEL: (855 63) 963 888
FAX: (855 63) 963 168
www.raffles.com

Australia

Bedarra Island Resort
Bedarra Island, Queensland,
Australia
TEL: (61 7) 4068 8233
FAX: (61 7) 4068 8215
www.poresorts.com

Bloomfield Rainforest Lodge
Cairns, Queensland, Australia
TEL: (61 7) 4035 9166
FAX: (61 2) 9999 4332
www.bloomfieldlodge.com.au

Dunk Island Resort
Great Barrier Reef, Australia
TEL: (61 7) 4068 8199
FAX: (61 7) 4068 8528
www.poresorts.com

Radisson Treetops Resort
Port Douglas, Queensland
Australia
TEL: (61 7) 4030 4333
FAX: (61 7) 4030 4323
www.radisson-resorts.com.au

Thala Beach Lodge
Port Douglas, Australia
TEL: (61 7) 409 85700
FAX: (61 7) 409 85837
www.thalabeach.com.au

The Caribbean and Mexico

Las Alamandas
Colima, Mexico
TEL: (52 322) 285 5500
FAX: (52 322) 285 5027
www.almandas.com

La Samanna
St. Martin, French West Indies
TEL: (590) 87 64 00
FAX: (590) 87 87 86
www.creativeleisure.com

Little Dix Bay Hotel
Virgin Gorda, British Virgin Isles
TEL: (284) 495 5555
FAX: (284) 495 5661
www.littledixbay.com

Mahakua-Hacienda de San Antonio
Colima, Mexico
TEL: (52 312) 313 4411
FAX: (52 312) 314 3727
www.amanresorts.com

Maroma Resort and Spa
Yucatan, Mexico
TEL: (52 998) 872 8200
FAX: (52 998) 872 8220
www.cancun.com

India

Amarvilâs Resort
Agra, India
TEL: (91 562) 231 515
FAX: (91 562) 231 516
www.rbrww.com

Cecil Resort
Shimla, India
TEL: (91 177) 20 4848
FAX: (91 177) 21 1024
www.rbrww.com

Rajvilâs Resort
Jaipur, Rajasthan, India
TEL: (91 141) 68 0101
FAX: (91 141) 68 0202
www.rbrww.com

Vanyavilâs Resort
Rajasthan, India
TEL: (91 7462) 23999
FAX: (91 7462) 23988
www.rbrww.com

Wildflower Hall
Shimla, India
TEL: (91 177) 480808
FAX: (91 177) 480909
wwww.rbrww.com

Europe

Anassa
Latchi, Cyprus
TEL: (357 6) 888000
FAX: (357 6) 322900
www.thanoshotels.com

Grand Hotel Villa Serbelloni
Bellagio, Italy
TEL: (39 031) 950 216
FAX: (39 031) 951 529
www.villaserbelloni.it

Hotel Cipriani
Venice, Italy
TEL: (39 041) 520 7744
FAX: (39 041) 520 3930
www.hotelcipriani.it

Hotel de La Cité
Carcassonne, France
TEL: (33 468) 71 98 71
FAX: (33 468) 71 50 15

Hotel Petali
Pano Petali, Sifnos, Greece
TEL: (003) 02840 33024
FAX: (003) 02840 33391
www.sitnus.com

Hotel Royal Riviera
St. Jean-Cap-Ferrat, France
TEL: (33 493) 76 31 00
FAX: (33 493) 01 23 07

Hotel San Pietro
Positano, Italy
TEL: (39 089) 87 54 55
FAX: (39 089) 81 14 49
www.ilsanpietro.it

Hotel Splendido
Portofino, Italy
TEL: (39 018) 526 7801
FAX: (39 018) 526 7806
www.splendido.orient-express.com

Palazzo Sasso
Ravello, Italy
TEL: (39 089) 818181
FAX: (39 089) 858900
www.palazzosasso.com

Reid's Palace
Madeira, Portugal
TEL: (351) 291 71 71 71
FAX: (351) 291 71 71 77

Villa San Michele
Florence, Italy
TEL: (39 055) 567 8200
FAX: (39 055) 567 8250
www.villasanmichele.orient-express.com

Indian Ocean

Banyan Tree Maldives
Vabbinfaru Island, Maldives
TEL: (960) 443 147
FAX: (960) 443 843
www.banyantree.com

Bird Island Lodge Hotel
Seychelles, Bird Island
TEL: (248) 323 322

Le Touessrok Hotel & Ile aux Cerfs
Trou d'Eau Douce, Mauritius
TEL: (230) 419 2451
FAX: (230) 419 2025

Middle East

Jebel Ali Hotel
Dubai, United Arab Emirates
TEL: (971 4) 836 000
www.jebelalihotels.com

North America

The Alexander
Miami Beach, Florida
TEL: (305) 865 6500
FAX: (305) 341 6553
www.alexanderhotel.com

Amangani
Jackson Hole, Wyoming
TEL: (307) 734 7333
FAX: (307) 734 7332
www.amanresorts.com

Delano
South Beach
Miami, Florida
TEL: (305) 672 2000
FAX: (305) 532 0099
www.delanohotelmiamibeach.com

Keswick Hall
Keswick, Virginia
TEL: (434) 979 3440
FAX: (434) 977 4171
www.keswick.com

Little Palm Island
Little Torch Key, Florida
TEL: (305) 872 2524
FAX: (305) 872 4843
www.littlepalmisland.com

WaterColor Inn
Seagrove Beach, Florida
TEL: (850) 534 5000
FAX: (850) 534 5001
www.watercolorinn.com

Wequassett Inn Resort and Golf Club
Pleasant Bay
Chatham, Massachusetts
TEL: (508) 432 5400
FAX: (508) 432 5032
www.wequassett.com

White Barn Inn
Kennebunkport, Maine
TEL: (207) 967 2321
FAX: (207) 967 1100
www. whitebarninn.com

South America

Copacabana Palace Hotel
Rio de Janeiro, Brazil
TEL: (55) 21 2548 7070
FAX: (55) 21 2235 7330

Machu Picchu Sanctuary Lodge
Machu Picchu, Cusco, Peru
TEL: (51 84) 24 1777

The South Pacific and Hawaii

Bora Bora Lagoon Resort
Vaitape, Bora Bora
French Polynesia
TEL: (689) 60 40 00
FAX: (689) 60 40 01

Hotel Bora Bora
Point Raititi, Bora Bora
French Polynesia
TEL: (689) 60 44 60
FAX: (689) 60 44 66
www.amanresorts.com

Kahala Mandarin Oriental
Honolulu, Hawaii
TEL: (808) 739 8888
FAX: (808) 739 8800
www.mandarin-oriental.com

Manale Bay Hotel
Lanai City, Hawaii
TEL: (808) 565 7700
FAX: (808) 565 2483

Vatulele Island Resort
Vatulele Island, Fiji
TEL: (679) 6550 300
FAX: (679) 6550 262

By Way of Sea

The Charter Pilgrimage

Admiralty Yacht Vacations
St. Thomas, Virgin Islands
TEL: (800) 544 0493
FAX: (340) 774 8010
www.admirals.com

***Irene* Yacht Charters**
Windsor, United Kingdom
TEL: (44 1753) 868 989
FAX: (44 1753) 842 852
www.ireness.com

The Far East Pilgrimage

Radisson Seven Seas Cruises
M/S *Song of Flower*
TEL: (800) 285 1835
FAX: (402) 431 5599
www.rssc.com

The Other Worldly Pilgrimage

Faraway Sail & Dive Expeditions
Phuket, Thailand
TEL: (66 76) 220507
FAX: (66 76) 280701
www.far-away.net

Palawan
Portland, Maine
TEL: (888) 284 7251
www.sailpalawan.com

The Pharaonic Pilgrimage

Oberoi Philae Nile Cruiser
Cairo, Egypt
TEL: (800) 233 5570
www.egyptvoyager.com

Pilgrimage with Panache

Seabourn Cruise Line
Pride, Spirit, and *Legend*
TEL: (305) 463 3000/(800) 929 9391
FAX: (305) 463 3010
www.seabourn.com

SailAway Yacht Charter Consultants
Bareboat Depot
Miami, Florida
TEL: (800) BAREBOAT
FAX: (305) 251 4408
www.bareboat.com

Seatrek—Anasia Cruises
Sanur, Bali
TEL: (62 361) 283 192
FAX: (62 361) 285 440
www.anasia-cruise.com

The South Seas Pilgrimage

Radisson Seven Seas Cruise
M/S *Paul Gaugin*
TEL: (800) 285 1835
FAX: (402) 431 5599
www.rssc.com

The Ultra-Pilgrimage

Queen Elizabeth 2
Cunard Line
TEL: (800) 7 CUNARD
FAX: (305) 269 6950
www.cunardline.com

The Wilderness Pilgrimage

Sunrise Expeditions
Bangor, Maine
TEL: (207) 942 9300
FAX: (207) 942 9399
www.sunrise-exp.com

Credits

Photography:

Ray Atkeson: 97, 100, 109
Daryl Benson: 2–3, 7, 35, 86, 118
Gideon Bosker: 75, 94
Barry Brukoff: 16, 70, 104, 105, 112
Gloria H. Chomica: 124
Ron Cronin: 64, 65, 68–69, 101
Dave Culverwell: 66
Eastcott and Momatuck: 33
Claude Fiddler: 38–39
 72–73, 95
Janet Foster: 13
A. Blake Gardner: 15, 114
Larry Geddis: 43, 44, 96
Karen Halverson: 27
Bruce Heinemann: 41
Stuart Klipper: 1, 26, 28–29, 30, 50
Lisa Lefkowitz: 77
Michael Martin: 91, 99, 117
Ted Mead: 20, 36, 54, 123, 126

Sheila Metzner: 62, 89
Joel Meyerowitz: 80, 82, 119
Richard Misrach: 8, 106–107, 132
David Muench: 19, 46, 48, 49, 55,
 56, 60, 61, 102
Albert Normandin: 110–111
Eliot Porter: 76, 78, 83, 85, 121
Rick Schafer: 88
Alison Shaw: 14
George Simhoni: 53
Brian Sytnyk: 120
Steve Terrill: 21, 23, 45, 92
Mark Tomalty: 18
Craig Tuttle: 40, 43, 58, 59
Art Wolfe: 34, 51
Brad Wrobleski: 24

Poetry:

Page 71: "Alturas de Macchu Picchu"
(excerpt) from *The Heights of Macchu
Picchu* by Pablo Neruda © Jonathan
Cape Ltd. Translation © Nathaniel
Tarn. Used by permission.

Page 81: "Rhapsody on the Sea"
(excerpt) from *Wen Xuan* by Xiao
Tong © 1987 Princeton University
Press. Translation © David R.
Knechtges. Used by permission.

Page 90: "Feelings before Friedrich's
Seascape" (excerpt) from *An Abyss
Deep Enough* by Heinrich von Kleist
© 1982 Philip B. Miller.

page 132: **Edom Hill Road** ✝ Southern California

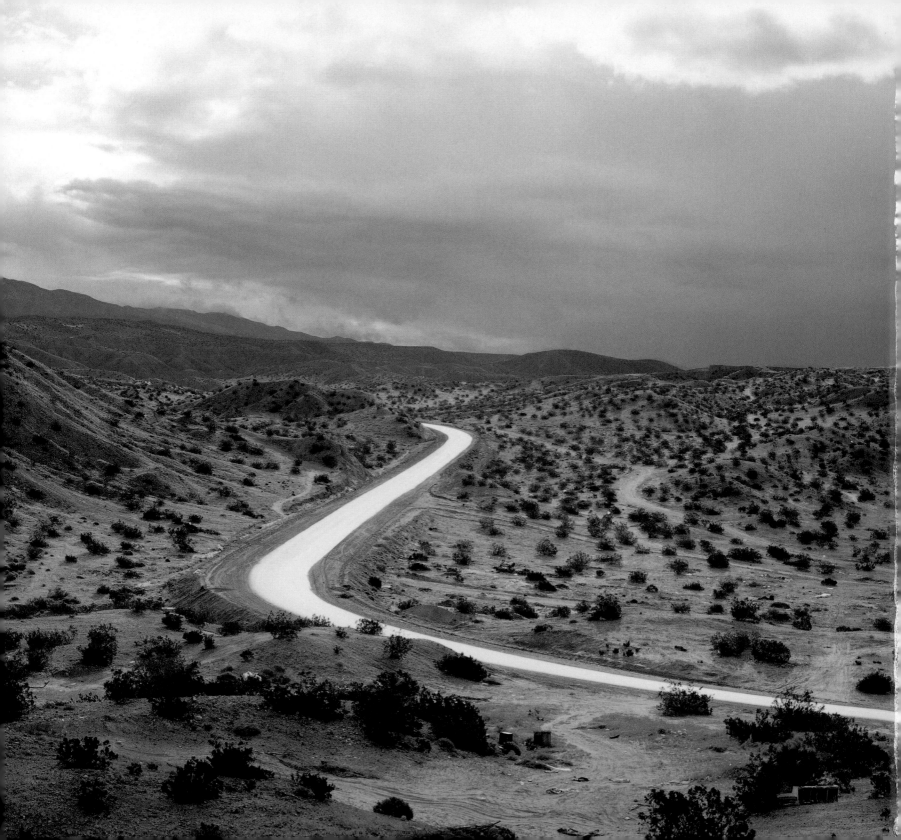